Viking and Slavic Ornamental Design
Graphical Catalogue with Rus Add-On

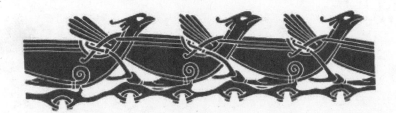

*We dedicate this book to our forefathers who bestowed
upon us a beautiful source of inspiration*

Triglav

Szczecin 2013

Original Title: *Zdobnictwo wczesnego średniowiecza. Katalog graficzny z dodatkiem „Ruś"*
Author: Igor D. Górewicz
Editor of the 1st Polish Edition: Igor D. Górewicz, Magda Górewicz
Illustrator: Marek Piłaszewicz
Translation:Michał Matynia
Cover Design: Igor D. Górewicz, Marek Piłaszewicz
© Copyright by Igor D. Górewicz

This book is published under license with Triglav Publishing in conjunction with:

Pike and Powder Publishing Group LLC

17 Paddock Drive
Lawrence, NJ 08648

1525 Hulse Rd, Unit 1
Point Pleasant, NJ 08742

(732) 714-7000

ISBN 978-1-945430-77-0
LCN 2019930154
Bibliographical References and Index
1. Science Fiction. 2. Alternate History. 3. Alien Invaders

Pike and Powder Publishing Group LLC All rights reserved
For more information on Pike and Powder Publishing Group, LLC,
visit us at www.PikeandPowder.com & www.wingedhussarpublishing.com
twitter: @pike_powder
facebook: @PikeandPowder

"Triglav" Publishing is a trademark of Trzygłów – Historical Reenactment Igor D. Górewicz
gorewicz@wp.pltel. (+48) 606 955 299 www.tryglaw.org

Introduction to English Edition

We hereby present you with an unusual book, thoroughly devoted to ornamentation and design in the Early Middle Ages. So far, only a scarce number of books pertaining to the topic of Early Medieval ornamentation were published in Europe. Still, even these catalogues focused mainly on artefacts from the Viking period and Western territories, which, in our perspective, did not quite meet the demand for more original patterns. Thus, we committed to find a less familiar selection of motifs, but also to assume a more original stance in presenting them graphically. Even more so, we strived to include detailed descriptions and references for every presented motif, which is, as some readers claim, a unique feature of this catalogue. Therefore, the catalogue incorporates archaeological location of every artefact, dating as well as symbolic significance and, whenever possible, stylistic links of each pattern.

The first publication of the catalogue, entitled "*Zdobnictwo wcze- snego Średniowiecza. Katalog Graficzny*" ["Ornamentation of the Early Middle Ages – The Graphic Catalogue"], came into being in 2006 in Polish language only. From the moment of its release, the publication was warmly welcomed by history and Art enthusiasts both at international Viking festivals and during museum exhibitions. The amount of this interest, however, was greatly limited due to the language in which the book was originally published and, along with our prospective readers, we hoped that the English edition is soon to follow. As promised, we present you with an updated English version of the catalogue, extended by over 60 additional patterns from the Rus territory that were only recently incorporated into Polish 2nd edition.

On this occasion, I would like to encourage you to browse through both introductions for Polish editions, as they explain in detail criteria that led to material selection as well as methodology of their presentation. All in all, we hope that our European public shall acknowledge clear and practical way in which we present you with the aesthetic heritage of European culture and its people.

Igor D. Górewicz Szczecin, 31 December 2008

Introduction to 2nd Edition

The book that you are holding is a 2nd edition of the catalogue devoted to Early Medieval patterns initially released in the year 2006. "Ornamentation of the Early Middle Ages" was a debut of Triglav Publishing and, from the time of its appearance, the catalogue received lots of positive feedback visible in an enormous popularity of the first release. This, in turn, convinced us that the principles inspiring our first publication, the same ones that led to the establishment Triglav Publishing, were right and that we should carry on in this direction. As soon as the first release of 1000 copies was coming to an end, we decided to put through a 2nd extended and improved edition.

The principles behind graphic presentation of the designs remained unchanged. Still, we did acknowledge that the collection ought to revolve around one particular theme. After a series of long and strenuous debates, we agreed not to group ornaments according to their compositional arrangement (spirals, zoomorphs, dendriforms), but instead focus on territorial origin of each decoration. In accordance with latest tendencies among Polish historical re-enactors of the Early Middle Ages, we decided to compile a collection of patterns from the Rus territory. Even more so, as this particular territory is becoming more and more popular among people looking for new historical inspirations, and also has a wealth of source material that discloses flourishing cultural exchange as well as influences from many other, more exotic, cultures. It was precisely the openness and cultural diversity visible in Rus decorations that corresponded so well with a preceding set of patterns referring to a plethora of varying traditions. The problem remained, however, what does it mean to be Rus? Are we allowed call that an object created in the Rus territory, or rather patterns bearing traces of Rus style and aesthetics? In our perspective, which is shared by many historical re-enactors, the location of original find is of much more importance than any stylistic links that one may come to develop.

Indeed, it is precisely the discovery site that accounts for objects' physical presence and divulges style influences on a given territory, which then formulate basis for further analysis. As far as analytical part is concerned, we tried to address any queries that may arise in the references attached, which, in our opinion, will help prospective artists and re-enactors in choosing the right pattern regardless of their needs. Thus, in terms of garment deco-ration, there is plenty of choice for everybody, including Norman period enthusiasts, Nomadic history devotees, admirers of local Slavic traditions, people fancying thriving courts of Rus nobility or even supporters of emerging Old Rus culture. More importantly, those more interested in cosmopolitan aspects of Early Medieval aesthetics will finally be able to embrace all of the mentioned influences in one artistic expression of this multifaceted region.

The presented collection of motifs was expanded from 281 to 343 patterns, which accounts for over 60 new ornaments illustrated in the add-on at the end of the catalogue. This solution allowed us to retain the original layout of the first edition that also includes Rus ornamentation not found in the expansion. However, in our attempt to avoid any confusion that may emerge, we decided to mark any Rus related ornaments with the letter "R", which, in turn, will

allow the reader to quickly identify and isolate patterns found in the Rus area or determined by Rus aesthetics and composition. led to material selection as well as methodology of their presentation. All in all, we hope that our European public shall acknowledge clear and practical way in which we present you with the aesthetic heritage of European culture and its people.

Igor D. Górewicz Szczecin, 30 December 2008

Introduction to 1st Edition

MATERIAL SELECTION

All of the graphics presented in this catalogue have one common denominator. All of them can be traced back to the Early Middle Ages, the period in European history beginning with the Great Migration (V-VI c.) until the end of XII c., when the European continent finally saw the feudal system being developed into a fully functional entity, recognized as a feature of the Middle Ages proper. During that time, a variety of ethnics and nations were shaped, some of which belonged to "barbarian" culture, especially among European tribes that remained in contact with Ancient, Mediterranean culture widely spread in Western Europe. Therefore, a different, geographical aspect of the presented material ought to be taken into consideration, aside from the period in which the imagery occurred. Accordingly, the imagery of choice for this particular catalogue is the one originating in Central, Eastern and Northern Europe, that is a region which was the last to enter a sphere of influence of the Roman Catholic (or Orthodox as was the case with Rus) Christianity, thus retaining its genuine, pagan character.

One ought to bear in mind, however, that native culture and aesthetics were never isolated entities and much as symbolism was of local provenance, one can still pinpoint the influences of the Ancients and Western culture. It was thus quite natural for the people of the mentioned region, such as Slavs, Balts, Magyars, also Saxons and Normans (Scandinavians), to participate in trade and cultural exchange. In particular, the Viking movement (793-1066), commonly associated with the Normans, contributed a great deal to spreading and interchanging various influences visible through Scandinavian artifacts excavated as far as Rus or Hungarian territory. Please note that even the choice of a symbol for the cover was not an arbitrary one, as this very symbol, representing overlapping circular shapes, is a reminiscence of cultural diversity and exchange mentioned previously. The motif on the cover is common in the Early Middle Ages, even among varying ethnic groups and territories, which points to its archaic provenance dated back to the Antiquity. The oldest examples of this motif in an unchanged form are dated back to 600 BC and were found in the context of Greek, Etruscan and Roman traditions. This, in turn, points to a kind of cultural continuity, the extent of influence as well as adaptive capabilities present in certain categories of cultures. In conclusion, the time frame for the material presented in the catalogue is set from VIII c. until as late as XII c. In terms of geography, the territorial extent of the motifs encompasses Poland, Lithuania, Latvia, Belarus, Ukraine, Russia, Czech Republic, Slovakia, Eastern Germany, Denmark, Sweden, Norway and Hungary. In some cases, the patterns presented are later that their counterparts and go as far as XIII c. These examples, however, were included on purpose as they show continuation of a trend, imagery and aesthetics in form not seen among their predecessors.

The preparation of this catalogue was an extremely time-consuming experience as it required getting acquainted with numerous publications on the topic, as well browsing through

thousands of pictures, illustrations and manuscripts where the motifs in question could be found. Still, the author did not strive to gather the patterns in a systematic fashion, such as would be expected from an academic paper. On the contrary, the choice of illustrations is a subjective one, valued more for their aesthetics and how well the motifs could be adapted in an artistic way, rather than their historical context. On the other hand, the author did try to achieve a sort of overview of all the decorative trends and styles in the Early Middle Ages, yet, no attempts were made at creating a comprehensive systematization of the mentioned trends, which accounts for variety lacks that one may come to address when reviewing the catalogue.

METHODOLOGY

The focal point of this catalogue is an ornamental motif itself, represented as a spiral hip, conjoint circular pattern, dendriform ornament, anthropomorphic shape or even a symbol. Bear in mind that every decoration was found in a context, on an object that had a function attached to ornamentation inscribed in it. The range of these objects is vast and includes jewelry, strap ends, mosaics, knife and spoon handles, ceramic and wooden bowls, antler and bone plates, embroidery, manuscript illuminations, sword grips, spears, spurs, ferrules, combs, saddles, stone engravings, portals and, last but not least, Romanesque columns. All of the motifs included in the catalogue were flattened to a basic two-dimensional shape, in order to expose their graphical values and structural design and omit details that tend to blur the pattern when presented in its original, three-dimensional form. When choosing the ornaments, we focused purely on their composition, thus all the motifs were devoid of a context or function carried by the object that these patterns decorated. This has been done on purpose, to enable artists to freely use a given pattern or shape and avoid implied function by linking it with an object on which it originally occurred.

In addition, certain motifs had to be simplified and their symmetry recovered, so as to fit the patterns better into aesthetics of today as well as modern demand for symmetry. Whenever an ornament was damaged, we strived to fill the gap in accordance with motif's repetitiveness and also the rules of symmetry. As for the technique, the computer was used mainly in symmetry recovery and fillings. Still, all the drawings were handmade and we struggled to bring the use of a computer to absolute minimum. All this was done to an aesthetic effect to leave the illustrations with all their imperfections, thus bringing them closer to the period in which they were originally created and, finally, avoid turning the poetic imagery of each graphic into a sterile picture devoid of significance and atmosphere of the period.

As far as artists are concerned, please be aware that fillings and edge thickenings that we used for illustrating the graphics are not final, so if you intend to use a given motif, feel free to experiment with different combi- nations, interchange fillings, you can even go beyond a simple negative. In case of more complex filling patterns, we aimed at showing that a number of color combinations are possible. Some patterns may even be interpreted as multicolored, richly decorated shapes excellent for embroidery or painting. With some decorations however, we left them unfilled to expose the complexity of a shape or its contours. By doing so we left it up to sculptors or tattooists to interpret ornament fillings. Finally, we would like to encourage you to change the

patterns, draw them fragmented, and bring them to new use in terms of their positioning and composition. For each motif that we included in the catalogue, a number of interpretations are possible, yet we usually opted for the clearest and most open variety. The only exception is a pattern of conjoint, overlapping circles which was commonly used and thus we decided to present an array of interpretations with different fillings and finishes.

CATALOGUE LAYOUT

The order of patterns as they occur in the catalogue was based solely on their artistic function as well as their usefulness when transferring them unto two-dimensional surface. In addition, each group of patterns was categorized according to a symbolic significance that they may carry. The only exception are anthropomorphic representations, since, due to their symbolic function, they are bound to become a thematic category themselves. Thus, the grouping begins with overlapping circular patterns that, due to their repetitive character, can be represented as straps or linings. Categorization follows with geometric, strap ornaments, and proceeds to spiral hips and dendriform shapes. The division continues with individual decorative patterns, starting dendriforms and spiral hips, and then zoomorphic and, occasionally, anthropomorphic motifs. The last part of the catalogue consists of shapes inscribed in circular, and later rectangular, form, starting from simple designs to more complex, intertwined patterns.

REFERENCES

The end of the catalogue includes references to original findings as well as the context in which a given ornament was found. These include information about an object on which ornament can be seen, material from which the object was made, its function, dating and find location. We also tried to incorporate comments regarding artistic trend or style a given pattern belongs to. Similarly, we strived to explain symbolic significance or interpretation whenever we felt it was interesting enough to inspire ornament recreation. As usual, we included information about the source of illustration for more inquisitive readers to trace the motif in other books or, alternatively, for the sake of individual research. The sources were numbered and added in square brackets with every illustration presented. However, bear in mind that numbers refer to one source only and in no way can such systematization function as a complete bibliography of any a specific ornament. In case of patterns referring to the Dictionary of Slavic Antiquity, we added page numbers to enable the reader to find quickly any desired pattern. In other cases, as the catalogue is not a part of academic curriculum, we let ourselves omit exact reference.

THE RECIPIENT

The catalogue is intended for artists and researches alike, people genuinely interested in old cultures, designers, digital artists, tattooists and people inspired by aesthetics of the Early Middle Ages. We expect that the booklet will also gain popularity among historical re-enactors, looking

for new, uncommon motifs to decorate their Slavic or Viking outfit, the group to which the author himself belongs to and is thus well acquainted with difficulties involving interesting decoration of historical garments, furniture and leatherwork. These and other problems inspired creation of this catalogue, with an intention to ease life of modern warriors and promote more variety in ornamentation as well as awareness of styles and periods which these ornaments were once part of. With this in mind, it is expected that re-enactors will have a better choice of ornamentation for the region and time that they are recreating, which, in turn, is bound to set a more realistic mood of the period. The catalogue may also be of interest to historians or even Art historians, Art students and anybody involved in appreciation of unfamiliar beauty and ancient aesthetics. The creators of this catalogue wish for Early Medieval stylistics to find its place in our aesthetic awareness and modern tastes, and also to find more value in the Art of Early Middle Ages that is still largely neglected and unappreciated.

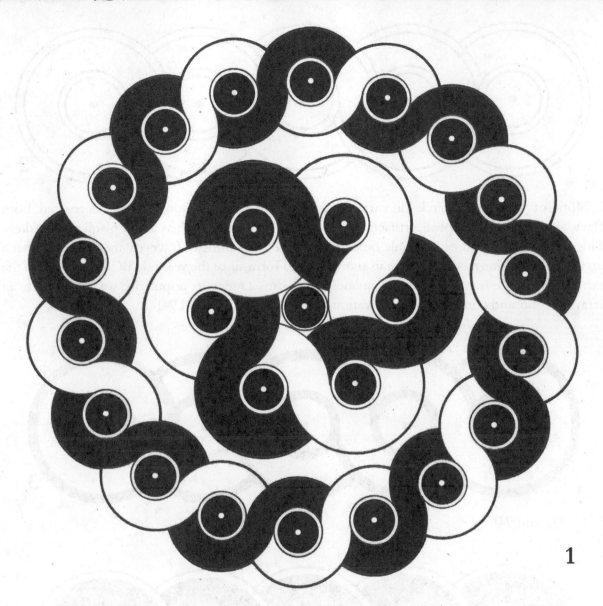

1

1. Pattern from a mosaic flooring in the southern nave of Gniezno Cathedral. The original was manufactured from ceramic tiles enameled with blue, yellow and green hued glaze. Whilst the exact dating is uncertain, the mosaic can be considered one of the oldest, as it was laid in an archaic fashion of old Romanesque shrines, possibly erected by Boleslav Chrobry. Please note exceptional skillfulness and aesthetics that the artist attempted to convey in the design, where the outer rim is made of 17 circular shapes, thus excluding the possibility of simplified geometric planning of the pattern. In our interpretation, the pattern consists of 18 circles. Please see below for motif meaning and its origin. [94]

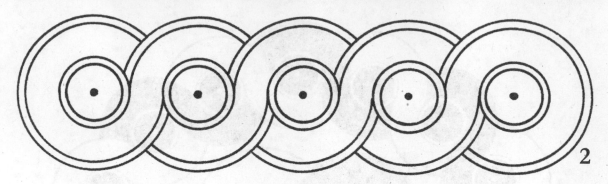

2

2. Motif of overlapping circles in various combinations was common on richly decorated, both Slavic and Western European, artifacts made of bone and antler, such as antler plaques on caskets. This particular pattern can roughly be dated to VIII-XII century. However, the motif has been prevalent in Mediterranean cultures in an unchanged form since the year 600 BC. According to the experts, the shape is reminiscent of aqueous symbolism. Due to its popularity, we present here an array of color and constructional derivations of the symbol. [72 and 94]

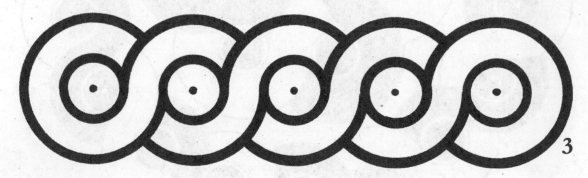

3

3. AA [72 and 94]

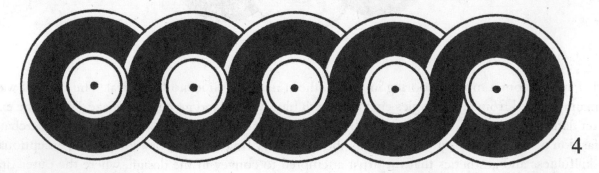

4

4. AA [72 and 94]

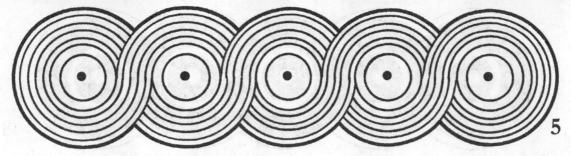

5. AA (this version of the pattern, based on a series of parallel lines, can also be seen on the casket found from Ostrów Lednicki) [72]

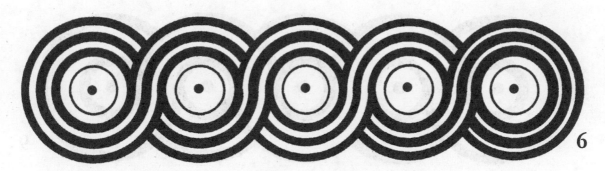

6. AA [72]

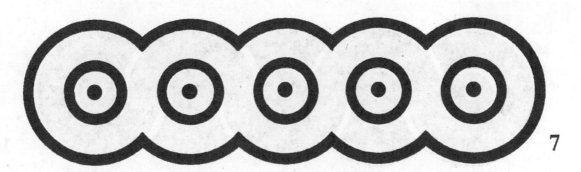

7. Another adaptation of the conjoint circles pattern present on this antler comb case from Kruszwica made around XI c. [22]

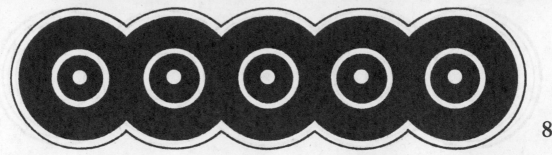

8

8. AA [22]

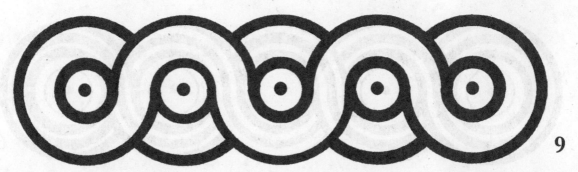

9

9. Different interpretation of the same pattern carved on a piece of T-shaped antler case from Mikulčice, Great Moravia, 1st half of IX c. [17] as well as on a knife hilt from Stare Město also in Moravia, IX-X c. [22]

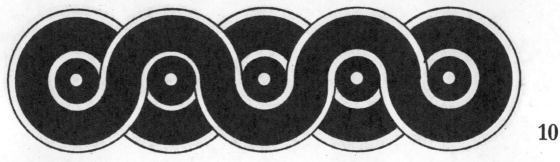

10

10. AA [17 and 22]

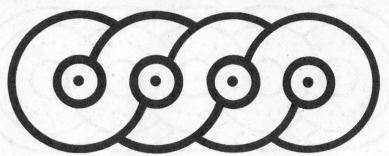

11 - This variant of the pattern appears carved on plaques of a number of caskets from Cologne [72]

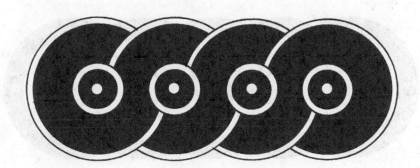

12 - AA [72]

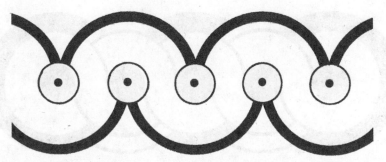

13 - This version is present on Callettes-les-Bois and Lüttich casket plaques. [72]

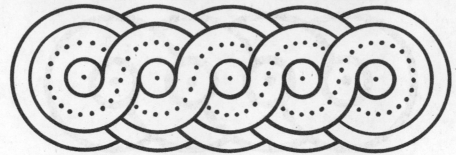

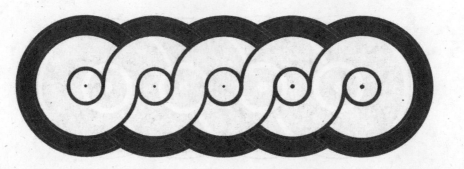

14

14 - Another, more ornamental adaptation of the conjoint circles motif visible on decorative antler plaques of a reliquary found in Essen-Werden (Germany), 2nd half of the VII c. [50]

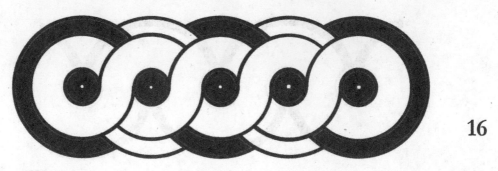

15

15 - AA [50]

16

16 - AM [50]

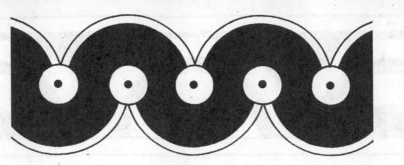

17 - Another spin-off of the conjoint circles pattern present, among others, on plaques of Callettes-les-Blois and Lüttich caskets [72]

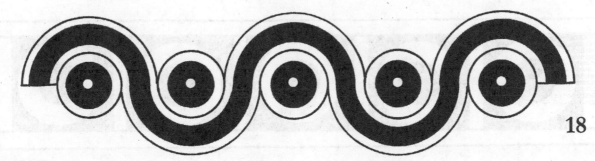

18 - This variant of the ornament can be found, among others, on an antler comb cladding from Budeč (Czech Republic), X c. [91]

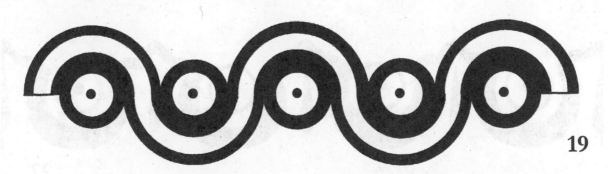

19 - AA [91]

20R

20R - Ornamental detail from the illumination appearing in Yurievan Manuscript found in St. George's monastery in Novgorod. [22]

21R

21R - AA [22]

22

22 - Archaic ornament on a silver goblet belonging to Preslavian bailiff Sivin, Preslav (Bulgaria), X c. [93]

23R

23R - Motif present on a sword hilt (guard and pommel) from Belarus, XII c. [54]

24R

24R - One of the patterns from Yurievan Manuscript illumination found in St. George's monastery in Novgorod, ca. 1120 AD [22]

25

25 - Ornament inlaid on a bronze bowl found in Dziekanowice (Poland), X c. [92]

26

26 - Piece of carving on a knife hilt from Szczecin, XII w. [64]

27

Fragment of a decoration on a beautiful, silver-gilded strap end from Jellinge (Denmark), X c. [13]

28

Ornament decorating edges of a reliquary lid from Kruszwica manufactured in French Limoges, XII c. [22 and 93]

29

29 - Decorative motif from Slavic temple ring found in the territory of today's Mecklenburg, Early Middle Ages [40]

30

30 - Pattern on a grip of a wooden ladle from Ostrów Lednicki, 2nd half of X-XI c. [75]

31

31 - Motif carved on a wooden spoon, Gdańsk, dated to X c. [21]

32 - Circular pattern decorating wooden hilt of a knife found in Slavic fort located in Gross Raden (Germany), Early Middle Ages [62]

33 - AA [62]

34 - Geometric shape occurring on the head of an awl grip from Wolin, X c. [11] 035 — Ornament carved in an antler plaque from Gniezno, X-XI c. [94]

35

35 - Ornament carved in an antler plaque from Gniezno, X-XI c. [94]

36

36 - Decoration of an astronomical manuscript, St. Gallen (Switzerland). ca. 1000 AD [91]

37

37 – Scandinavian decoration of a metal nahajka bolster, the motif is also referred to as Ahli pattern, Olontes in Karelia, XIII c. [30]

38

38 - Pattern from a temple ring found in princess' burial in Dębczyno, XII c. [36]

39

39 - Motif decorating a silver and copper incrusted stirrup from Ostrów Lednicki from before 1038 AD [31]

40

40 - AA [31]

41 - Common form of ornamentation on bone and antler artifacts, in the example given the design was copied from an antler comb, Wolin, X c. [11]

42 - Geometric pattern used on Early Medieval pottery [41]

43 - Slavic ornaments the Early Middle Ages were often used as ceramics decoration, X-XII c. [39]

44 - Slavic ornament was often carved on all sorts of antler artifacts. The circular shape with a hole in the middle was perforated with a hand drill and can be associated with solar symbolism, Early Middle Ages [39]

45 - Another widely spread pattern often seen on Slavic antlerwork, here used for container decoration, Krzyżowniki (Greater Poland), IX-X c. (interpretation) [17]

46 - Multiplication of a preceding, container decoration (interpretation) [17]

47 - Ornament used for decorating bone and antler merchandise, X-XII c. [39]

48 - Pattern on an antler needle case from Samborc (Poland), XI-XII c. [66, p. 239]

49 - See item 044 [39]

50

50 - AA decorating antler plaques on a casket found in Kamień Pomorski, XI-XII c. [72]

51

51 - AA [72]

52

52 - Decorative silver embroidery on a knife sheath of Slavic origin was accomplished with bronze wire. The artifact was found in Gruczno (Poland). Similar patterning is present on bronze sheaths (also from Gruczno) as well as hollow temple rings [41]

53

53 - Motif from Carolingian, Mannheim-type sword found in Hohenstaaten (Germany), VIII c. [9]

54

54 - Ornament often seen on relics of both Scandinavian and Slavic origin, such as the one presented here encircling eagle imagery on a wooden kaptorga (amulet case) excavated in Wolin, X c. [11]

55

55 - Motif on a crock from the treasure unearthed in Nagyszentmiklós (today's Sînnicolau Mare in Romania), IX-XI c. (see also no. 112 and 113) [67, p. 345]

56

56 - Pattern present on an antler horn from Staré Město (Moravia) ca. IX c. (previously this motif was an extension of the ornament no. 149) [22]

57R

57R - Geometric shape on a comb excavated in Rus territory, IX c. [70, p. 97]

58

58 - Ornamental pattern on bronze plate rings, Staré Město (Moravia), IX-X c. [22]

59 - Slavic ornament commonly used for decorating antler and bone merchandise, X-XII c. [39]

60 - AA but used for pottery [39]

61 - Decorative pattern on bronze plate rings, Staré Město (Moravia), IX-X c. [22]

62

62 - Ornament from a silver kaptorga (amulet receptacle) filigreed with wire Stará Kouřim (Czech Republic), beginning of X c. [22]

63

63 - Example of silver incrustation on Great Moravian spur found in the warrior grave in Ducove (Slovakia), 2nd half of IX c. [91]

64

64 - Ornamental design present on a chape unearthed in Dziekanowice (Poland), 2nd half of XI c. - end of XII c. [63]

65

65 - AA [63]

66R

66R - Ornament in Northern Germanic style, engraved and incrusted on the sword guard found in Gluchowca (Ukraine), possibly the item was manufactured locally, beginning of XI c. [28]

67

67 - Ornament from hilt guard and pommel of a sword excavated in Kokemäki Kakkulainen (Finland). It is possible that the pattern is tied to spur imagery, even more so as horseback and warrior gear shared close symbolism signifying courage and the status of warrior elite, X c. [45]

68

68 - Decoration on a side of a wooden pin found in Wolin (Poland), XI c. [11]

69

69 - Pattern decorating backside of the same pin [11]

70

70 - Ornamental motif from a marble slab (possibly belonging to alter partition) found in the Church of St. Donatus in Zadar (Croatia), XI c. [65, p. 321]

71R

71R - Patterning on a bow, part of a gilded bronze cloak pin excavated in Kiev (fragment of an identical pin was also found near Volga River). As for the pin itself, it belongs to Scandinavian Borre style with traces of Ringerike style, examples of which appear in central Sweden and Gotland. Yet, the patterning of conjoint circles is not to be seen on any of Scandinavian relics, thus one can assume its local origin, 2nd half of X c. [8]

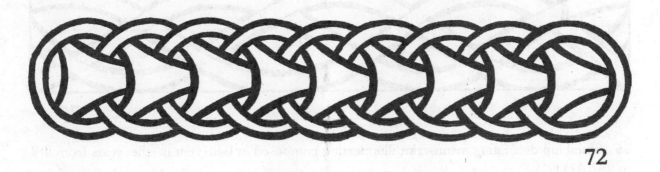

72

72 - Spiral hip belonging to Scandinavian Borre style from, so called," naval knife" found in Wolin harbor, beginning of XI c. [11]

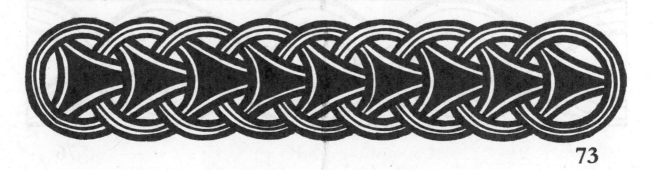

73

73 - AA in colored interpretation [11]

74

74 - Ornament on a relief with inscription from Croatian prince Branimir dated to 888 AD, Šopot near Benkovac (Croatia) [66, p. 279]

75

75 - Spiral hip decorating manuscript illumination composed in Bénévent in the years from 981 to 987 AD [91]

76

76 - Spiral hip encircling the Tree of Life present on a silver, Great Moravian strap end, Mikulcice (Czech Republic), IX w. [91]

77 - Wooden spoon carving from Gdańsk (Poland), Early Middle Ages after 2nd half of X c. [21]

78 - Ornament on a Romanesque pillar, Olomouc (Czech Republic), XII c. [65, p. 291]

79R - Decoration on ritual wrist bracelets, Kiev XII c. Bracelets of this sort shared a common heritage of significance linked with pagan elemental imagery, for example, as is the case with the presented item, aqueous symbolism (reference to the same bracelet in no. 134, see also no. 200) [59 and 93]

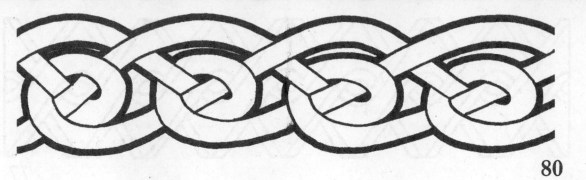

80

80 - Spiral hip encircling the image on a runic stone, Stenkyrka Smiss (Gotland), 1st half of VIII c. [23]

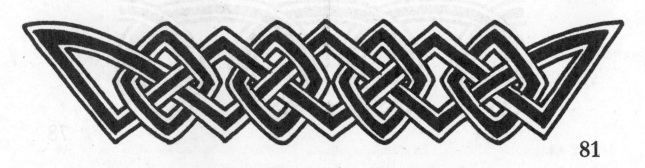

81

81 - Ornament on wooden cathedral doors, Split (Croatia), XII c. [65, p. 210]

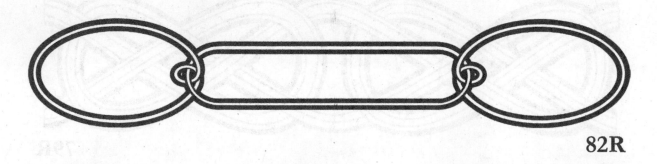

82R

82R - Simplified spiral hip on a hilt guard from a sword unearthed in Zaporizhia close to the Dnepr River. The sword's type and ornament bears resemblance to Carolingian ornamental tastes, X/XI c. (from the same group of hilt guard ornament on type-S swords, see 084, 086, 087, 093, 094) [28]

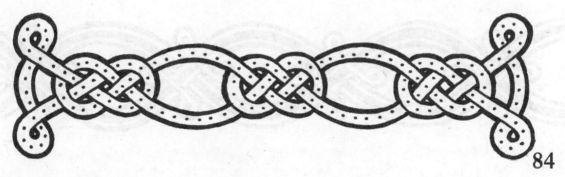

83 - Spiral hip from T initial in Kazania Wielkopostne manuscript kept in the Krakow Carthedral, beginning of IX c. [39]

84 - Patterning on a sword excavated in Morzew (close to the Noteć River), X c. (from the group of hilt guard ornament on type-S swords, see 082, 086, 087, 093, 094)

85R - Spiral hip in Carolingian style. Incrustation on a sword guard found in Podhorce, Plisneśk (Ukraine), X/XI c. [28]

86

86 - Incrusted spiral hip on a hilt guard and pommel of the sword excavated in Lipiany in Western Pomerania, X c. (from the group of hilt guard ornament on type-S swords, see 082, 086, 087, 093, 094) [38]

87

87 - Spiral hip ornament often visible on hilt guards and pommels of type-S swords from X and XI c. The ornament can be linked to spreading Scandinavian influences. Still, the ornamental style present on this type of swords does not attempt to duplicate Scandinavian design, but is a reminiscence of Carolingian aesthetics, such as a specimen found in Szob-Keiserdő (Hungary) (from the group of hilt guard ornament on type-S swords, see 082, 086, 087, 093, 094) [91]

88

88 - Spiral hip on a wooden knife hilt unearthed in Wolin, manufactured from a tree cut down after 907-911 AD [74]

89R - Symmetrical ornament, consisting of two rows of anthemions (of Eastern origin) conjoined with a spiral hip, is the evidence of interweaving influences of Slavic culture with the East, which was typical of Kievan Rus X-XI c. This particular ornament is present on a bronze sword guard, Kiev (Ukraine), ca. 1000 AD [28]

90 - Relief ornament representing a horseman, Žrnovnica (Croatia), beginning of XII c. [71, p. 263]

91R - Pattern decorating a chair rest, Novgorod, beginning of XIII c. [22]

92 - Spiral hip on a wooden hilt found in Wolin, X c. (the same item as no. 105) [11]

93R - Silver and copper incrusted decoration on a hilt guard from a sword found in Zaporizhia (Ukraine). This type of sword is of Carolingian origin, X/XI c. (from the group of hilt guard ornaments on type-S swords, see 082, 086, 087, 093, 094) [28]

94

94 - Decoration on a guard of type-S sword excavated in Greater Poland, X c. (from the group of hilt guard ornaments on type-S swords, see 082, 086, 087, 093, 094) [45]

95

95 - Characteristic ornament in Jellinge style is of Scandinavian origin, yet it emulates Anglo-Carolingian zoomorphic style. The item presented here was found on type-S sword hilt from Busdorf (Germany), X c. [45]

96

96 - Decorative motif of Norwegian origin on a wooden tray found in Slavic settlement in the territory of today's Berlin-Spandau (Germany), X/XI c. (same object shown in no. 193) [40]

97

97 - Full ornament on a wooden hilt of a knife excavated in Santok. It is believed, however, that the knife was manufactured in Wolin, as the patterning on the hilt bears close resemblance to Wolinian decorative trends, X c. (see also 98, 99, 102, 103, 104) [7]

98

98 - Spiral hip adorning edges of a vessel found in Wrocław, Early Middle Ages (the motif is a reminiscence of Wolinian style, see also 97, 99, 102, 103, 104) [21]

99

99 - Simplified fragment of an ornament from the object no. 104 (see also 97, 98, 102, 103) [7]

100

100 - Engraving on a knife hilt found in Szczecin, XII c. (see below no. 101) [64]

101

101 – Simplified and modified variant of a pattern from the object no. 100 [64]

102

102 - Ornament based on a convolution of " hanging triangles" on a wooden artifact unearthed in Wolin. According to the experts, the aesthetics of this ornament are representative of the style developed in Wolin, X c. (see also 97, 98, 99, 103, 104) [11]

103

103 - Ornamentation of a wooden hilt from Wolin, beginning of XI c. (see also 97, 98, 99, 102, 104) [73]

104

104 - Decoration on an antler hilt excavated in Swedish Birka, possibly imported from Wolin, X c. (see also 97, 98, 99, 102, 103) [7]

105

105 - Spiral hip on a wooden hilt found in Wolin, X c. (same item as no. 092) [11]

106

106 - Spiral ornament on a stone slab, Split (Croatia), XII c. [69, p.363]

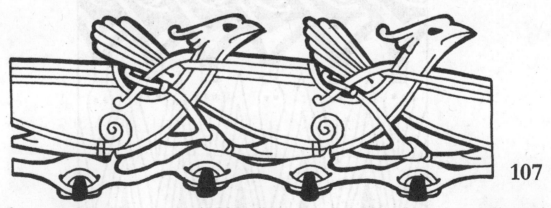

107

107 - Bird-type, zoomorphic ornament in Ringerike style on a ferrule of a rim decorating early drinking horn found in Aarhus (Denmark) dated to X/XI c. This style exposes foreign influences on Scandinavian Art, mainly those from the territory of today's England [58]

108 - Ornament from, so called," Gniezno gate", XII w. [AO in 84]

109 - Ornament on a wooden casket from Kamień Pomorski, XI-XII c. [72]

110 - Ornament on a gilded-bronze book clasp (the clasp comes from a collection of so-called relics), Ostrów Lednicki, X c. [16]

111

111 - Ornament on a silver bowl from the treasure excavated in Ziemianski Vrbovka (Slovakia), 2nd half of VII c. [40]

112

112 - Ornament of a roundel edging on one of golden pots from the Nagyszentmiklós treasure (today's Sînnicolau Mare, Romania). The design indicates interweaving Hellenistic and Iranian influences and is attributed to Proto-Bulgarians, possibly Avars or Hungarians. The pots were most probably manufactured in Caucasian territory, IX-XI c. [67, p. 364]

113

113 - Ornament at the bottom of a famous golden vessel (same as no. 055) found in the Nagyszentmiklós treasure, AA [67, p. 364]

114

114 - Patterning on a gilded-bronze ferrule of a wooden plate, Ostrów Lednicki, X c. [51]

115

115 - Decoration on an openwork, horn ferrule Kruszwica, XII-XIII c. [22]

116

116R - Spiral hip ornament on a bronze sword guard found in Karabcijewo, (Ukraine) XI c. (the same sword was presented in no. 126 and 127) [28 and 45]

117

117R - Motif seen on an aurochs horn's silver ferrule excavated from" Czarna Mogiła", an example of Khazar influences, beginning of X c. (see also no. 156) [22]

118

118 - Ornament on a silver goblet belonging to Preslavian bailiff Sivin, Preslav (Bulgaria), beginning of X c. [93]

119

119 - Gold incrusted motif on a princely spear sheath, Stara Kouřim, (Czechy) IX c. [93]

120

120 - Ornament on a marble plaque from the Church of Ravenna (Italy), an example of Byzantine influences transfigured by Longobards , VII c. [72]

121

121 - Decoration on a K-type sword, Ballindery Crannog, (Ireland) IX c. [45]

122

122 – Motif on an antler cup from Gniezno, XI-XII c. [86]

123

123 - Ornament on a silver goblet belonging to Preslavian bailiff Sivin, Preslav (Bulgaria), beginning of X c. [93]

124

124 - Copper and brass incrusted motif of a heart shaped spiral hip seen on an iron stirrup discovered in the Avon River. This type of incrustation is of Anglo-Saxon origin, 2nd half of X c. - beginning of XI c. [25]

125

125 - Ornament found in" Kodeks Wyszechradzki" composed in Czech Republic during 2nd half of XI c. (possibly around 1086 AD) [66, p. 437]

126R

126 - Dendriform pattern on a bronze hip of a sword excavated in Karabcijewo. The ornament is characteristic of Kievan Rus XI-XII c., (Ukraine), XI c. (see above no. 127, also no. 116) [28 and 45]

127R

127R - Fragment of an ornament decorating the item above (126) (patterning on the same sword is also visible in no. 116) [28 and 45]

128R

128R - Ornament on a clay plaque, Kievan Rus, ca. XII c. [22]

129R – Decoration of a silver strap end from a princely burial in Čadjavica (Chorwacja), VII c. The grave indicates traces of Slavic colonization in Northern Yugoslavia, originating in Western Ukraine (see below 130) [93]

130R – Motif on a strap end from the" Martynowka" treasure (Ukraine) ca. VI c. or beginning of VII c. The treasure was localized in the middle of Dnepr territory inhabited by the Slavic Ant tribe akin to Iranian tribes (see above 129, also comment for no. 146) [93]

131

131 - Embroidered motif on a silk pouch from warrior burial in Starogard Wagryjski (Oldenburg/ Germany), X c. [91]

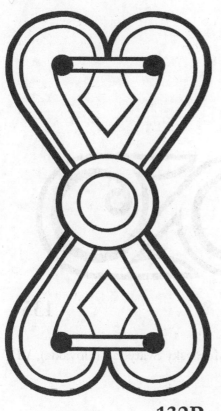

133

132R - Motif on a Rus sword hilt of a local type, X-XI c. [28]

133– Avar motif on a belt end, Dobrzeń Mały (Upper Silesia), end of VIII c. [12]

132R

134R

134R - See no. 79, motif symbolizing the world of fruitful vegetation in both aboveground and underground (roots) perspective (see also no. 200) [93]

135

135 - Spiral hip ornament from a bronze, openwork belt end, Moravský Svätý Ján (Slovakia), VIII c. [46]

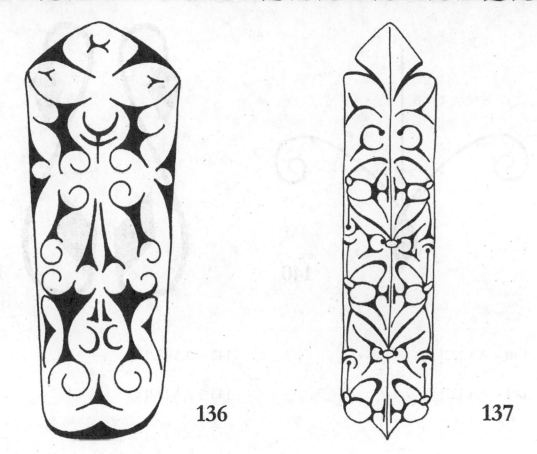

136

137

136 – Magyar motif on an antler bridle decoration, Edeleny-Borsod (Hungary), X c. [91]

137 – Magyar motif on an antler bridle decoration, Saly-Lator (Hungary), X c. [91]

138

139

138 – Motif found on leather shoes from Opole, XI-XII c. [22]

139 – AA [22]

140

141

140 – AA [22]

142 – AA [22]

141 – AA [22]

143 – AA [22]

142

143

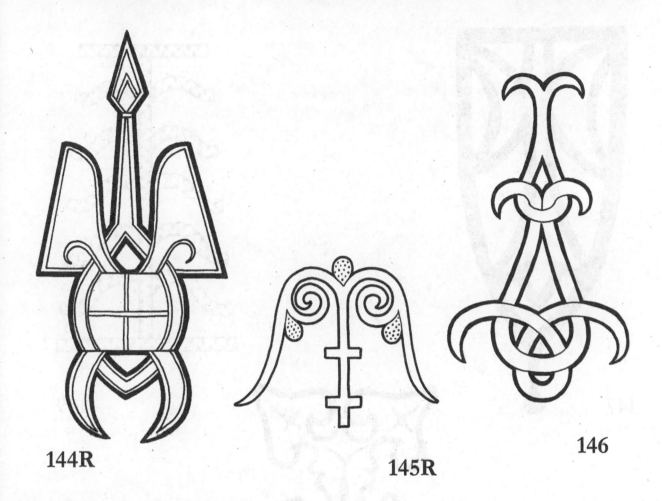

144R

145R

146

144R - Tridental ornament (trident, falcon, were traditionally attributed to Rurik dynasty, today trident is a national emblem of Ukraine) visible on an antler container from Kievan Rus (Žovnin, Ukraine), X-XIII c. [17]

145R – Symbol engraved on the head of a Rus axe excavated in middle Powołże. The symbol is a reminiscence of tamga, a type of symbol used by the Nomadic tribes, a pattern which may have later evolved to Polish crests. [29]

146 – Motif on a ladle excavated in Ostrów Lednicki, between 2nd half of X c. and XI c. [75]

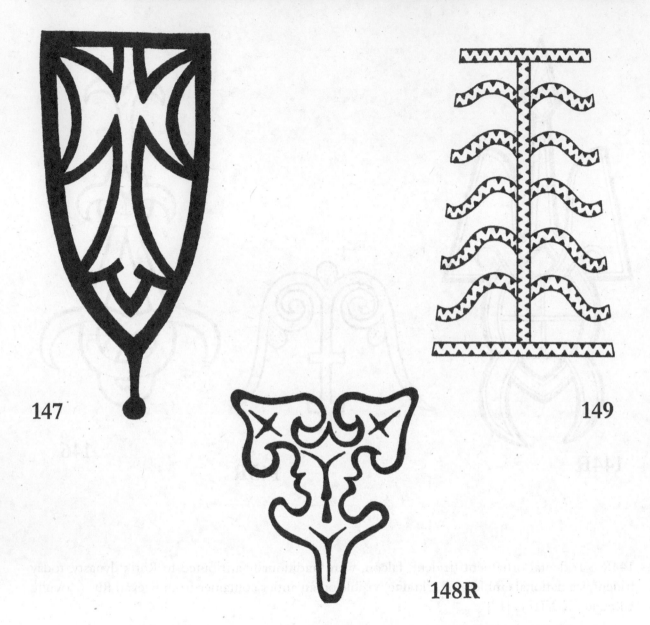

147

148R

149

147 – Bronze belt end, Starogard Wagryjski (Oldenburg / Germany), between middle of VIII c. - beginning of IX c. [9]

148R – Ornament resembling three lilies carved on a bark plaque found in the compound of a Byelorussian hut in Dawidgródek, after XI c. [53]

149 – Pattern present on an antler horn from Staré Město (Moravia), ca. IX c. (previously this motif was an extension of the ornament no. 056) [22]

150

151

152

150 – Motif on a gilded silver strap end from Avar, princely barrow, Zeplin (Slovakia), X c. [91]

151 – Piece of ornament visible in the illumination found in "Ewangeliarz Dobrejszy" from around 1221 AD, possibly of Macedonian provenance where Byzantine influences merge with Western aesthetics [65, p. 198]

152 – Ferrule decoration, Styrmen (Bulgaria), IX-X c. [22]

153 – Ornament on a pillar head localized in Cistercian chapterhouse, Wąchock, XII c. [70, p. 353]

154 – Spiral hip on a small belt end of late Avar design found in a Slavic princely burial from the beginning of IX c., Blatnica (Slovakia) [91]

155 – Silver ferrules on a stirrup from late Avar princely barrow, Zeplin (Slovakia) X c. [91]

156R

157

158

159

156R – Motif seen on an aurochs horn's silver ferrule excavated in" Czarna Mogiła", an example of Khazar influences, Czernihov (Ukraine) beginning of X c. (see also no. 117) [22]

157 – Motif on silver, Great Moravian earrings excavated in Ducove (Slovakia), end of XI c. [91]

158 – Decorative piece seen on main belt ends in late Avar style from Slavic princely grave dated to the beginning of IX c., Blatnica (Slovakia) [91]

159 – Decorative motif on ceramic plaques from Wyszehrad, Prague, 2nd half of XI and XII c. [40]

160 – Pattern on a decorative, silver ferrule of a Byzantine book, turn of X-XI c. [91]

161 – The "Tree of Life" from Great Moravian, silver strap end, Mikulcice (Czech Republic), IX c. [91]

162 – Extension of a temple ring motif found in Dankowice, XI c. [2]

163 – Patterning on a relief from St. Stephen's Church in Sušćepan (Montenegro), XI c. [71, p. 130]

164 – Ornament on an openwork, antler plaque, Giecz X-XI c. [16]

165

165 – Ornament in Ottonic style visible on a parchment composed in Fleury, end of X c. (similar decorations are known from Nimes in France as well as Rome) [91]

166

166 – Spiral hip from an engraved parquetry in Romanesque church in Wiślica, XII c. [70, p. 498]

167R

167R – Motif on a bronze arch of the cult Ark found in the altar of Wszczyż Orthodox chapel (Russia), middle of XII c. The entire arch has been accomplished by a Russian master Constantine and was manufactured in accordance with local traditions. Despite its mainly Christian function, the artist managed to convey traces of traditional aesthetics and beliefs, where the Ark was attributed the imagery from local mythology linked with how the world was constructed and perceived by those pagan descendants. The illustrated pattern represents the world at its geotic layer. (see also no. 169) [22]

168

168 – Stirrup decorating motif (same as 214). [22]

169

169R – See no. 167, this pattern, however, represents the world at its celestial layer.

170

170 – Scandinavian motif in Urnes style from a runic stone in Gotland, ca. 1100 AD [91]

171

171 – Silver incrusted sword decoration from Pokrzywnica Wielka, most probably of Baltic origin, XII c. [45]

172

172 – Motif on a pillar head in the church of St. Nicolas, Potvorov (Czech Republic) XIII c. [68, p. 252]

173 – Motif on a Scandinavian plate pin found in Slavic settlement in Starogard Wagryjski (Oldenburg / Germany), 2nd half of VII c. [9]

174 – Scandinavian design on an antler plaque, Parchim-Lödigsee (Germany), XI/XII c. [91]

175R

175R – Ornament on a quiver ferrule, Stara Riazań XI-XII c. [22]

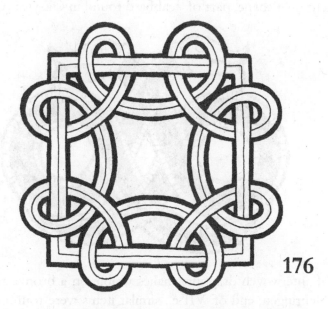

176

176 – Ornament visible on a strap ferrule, part of a sumptuous stirrup excavated in Starog-ard Wagryjski Oldenburg / Germany), X c. [26]

177

178

177 – Spiral hip on a Romanesque capital found in Banoštor (close to Nowy Sad, Serbia), XII c., possibly part of Benedictine monastery [72, p. 404]

178 – Ornament on a chape, part of scabbard found in Oksywa (Gdynia), XI c. [41]

179

179 – Motif of interwoven dragons/snakes visible on a bronze pin uncovered in the Trebel River, Nehringen, end of VII c., similar items were found in Gotland and Finland [9]

180

180 – Ornament on a richly decorated maniple of St. Ulrich, Southern Germany, 3rd quarter of X c. [91]

181

181 – Side shot of a coil motif made in accordance with Scandinavian Borre style, carved on a wooden knife hilt found in Wolin, turn of X/XI c. [74]

182R

182R – Ornament on an antler comb from Kamna (close to Pskov, Russia), VII-VIII c. [66, p. 363]

183

183 – Ornament on a Scandinavian threefoil pin, Kołobrzeg, middle of IX c. (pins of this type were of Scandinavian origin, which, in terms of style, were a transfiguration of Frankish jewelry consisting of three sides to hold a three-strap baldric) [43]

184

184 – Ornament visible on a strap plaque, part of a sumptuous stirrup excavated in Jütland (Denmark), X c. [26]

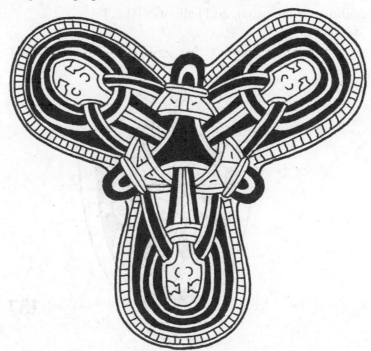

185

185 – Scandinavian pattern on a bronze pin unearthed in Slavic settlement of Stara Lubeka (Germany), beginning of IX c. (see also no. 183) [9]

186

186 – Ornamentation in Anglo-Carolingian style from a strap end found in Starogard Wagryjski (Oldenburg / Germany), 2nd half of VIII c. [9]

187

187 – Ornament on a scabbard shoe, part of scabbard found in Rybiczyzna (Poland), XI c. [40] with strongly over stylized "bird" motif entangled by a dragon/snake. The motif is of Scandinavian design combining Jellinge and Mammen styles, X c. [52]

188

188 – Ornamental motif on a scabbard throat found in Dybäck in Scania (Southern Sweden). The design indicates strong Anglo-Saxon influences, possibly the item was even manufactured in England as swords of this type were produced in Winchester, XI c. [18]

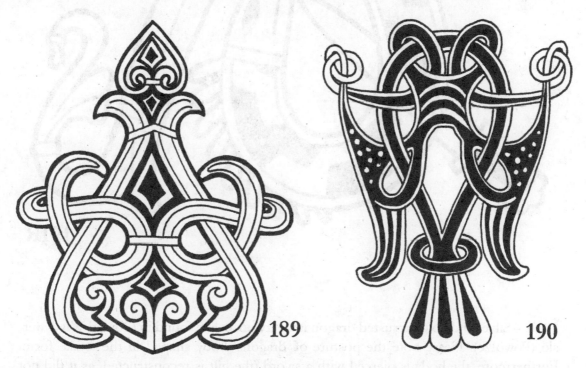

189

190

189 – Decoration on a scabbard shoe from the "Trzcinica treasure" (Kotlina Karpacka), XI c. (?) [84]

190 – Scandinavian" bird" motif on a scabbard shoe from Gårdby, Öland, X c. [52]

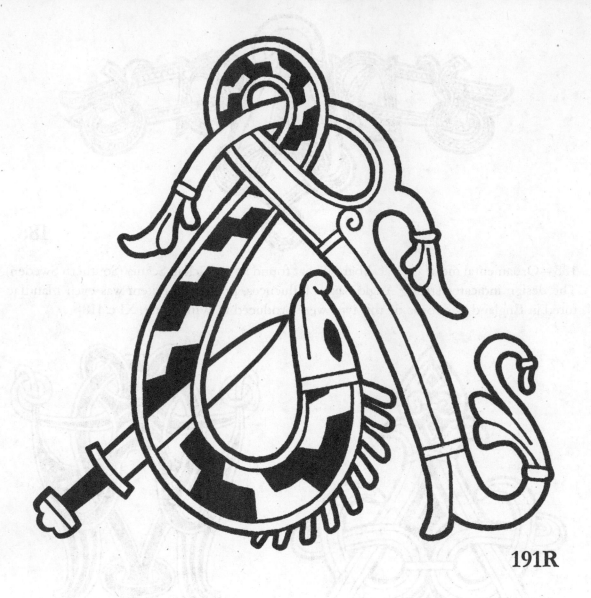

191R

191R – Silver and gold incrusted dragon imagery on an axe found in Obwod Władymir-ski (Powołże). Please note the posture of dragons' body shaped in the A-like form. Furthermore, the body is pierced with a sword (the hilt is reconstructed. as it did not survive in the original incrustation), which points to a mythological reference of the scene, representing one of Russian bylina protagonists – Dobrynia. What is more, the experts confirmed that the incrustation also bears some Scandinavian influences. [29]

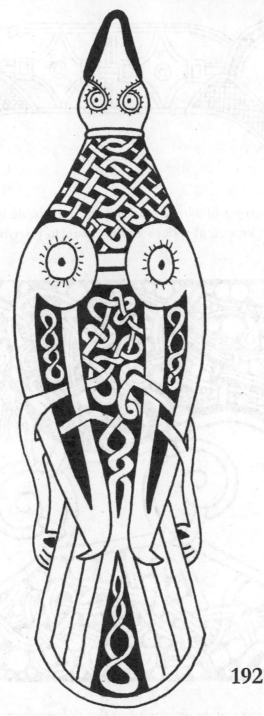

192

192 – So called" bird" pin discovered in Slavic settlement in Rostock-Dierkow (today's Germany), middle of VII – beginning of VIII c. [9]

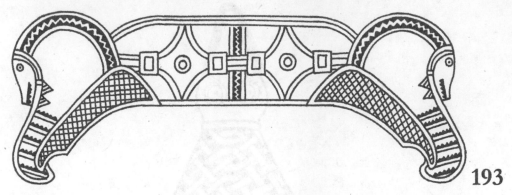

193

193 – Decorative pattern of Norwegian origin, here visible on a wooden tray excavated in Slavic settlement located in today's Berlin-Spandau (Germany), X/XI c. (see also no. 096) [40]

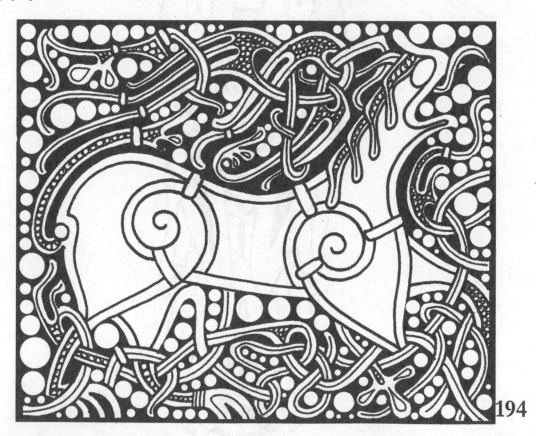

194

194 – Relief carving visible on one of antler coffers from a reliquary of St. Kordula found in Kamień Pomorski, an example of circumvoluted - zoomorphic design characteristic of Mammen style imported from Scandinavia, X/XI c. (possibly around the year 1000 AD) [39]

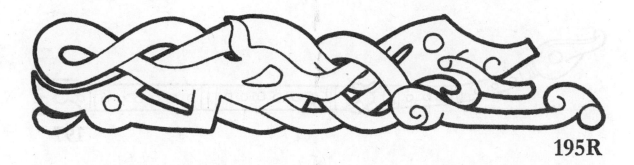

195R

195R – Motif of a mythical animal present on relief carving of a bronze plate that was used for production of sword hilts in Foszcziewataja (close to Kiev, Ukraine). The motif bears resemblance to Scandinavian Mammen style commonly used for decorating Swedish stelae of XI c., yet the experts agree with all certainty to South-Eastern, Baltic origin of the sword. [28]

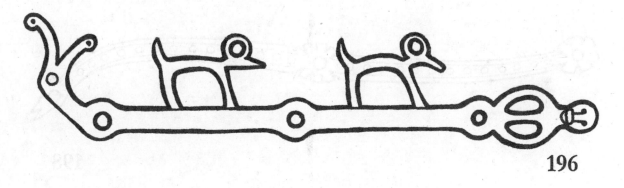

196

196 – Pattern from a richly decorated knife scabbard bearing some unknown mythological significance, Ostrów Lednicki, X-XI c. [51]

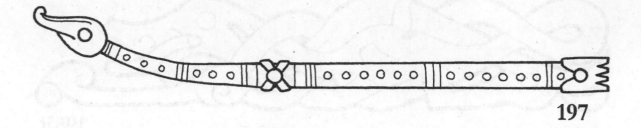

197

197 – Bronze scabbard ferrule of a knife found in Kałdusa, the form of the scabbard is Western Slavic, yet its decoration was maintained in Scandinavian Mammen style to a syncretic effect. [3]

198

198 – AA, object found in close vicinity of a preceding item no. 197. Still, in the presented artifact, the beast's head was not decorated in the mentioned Mammen style [3]

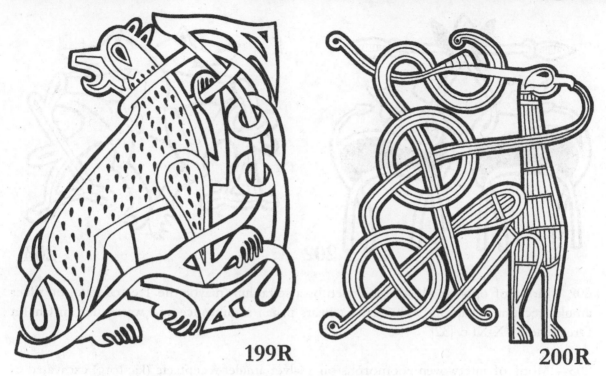

199R　　　　**200R**

199R – Motif on a fragment of relief from Borys and Gleba Orthodox chapel, Czernihov (Ukraine), XII c. [22]

200R – Depiction of a long-necked bird, probably a crane, in a symbolic composition on a silver bracelet from Michajłowski monastery in Kiev, XII-XIII c. (see also no. 79 and 134). According to the experts, crane is symbolically linked to the Sun and, similarly, holds the significance of fertility and welfare. [59]

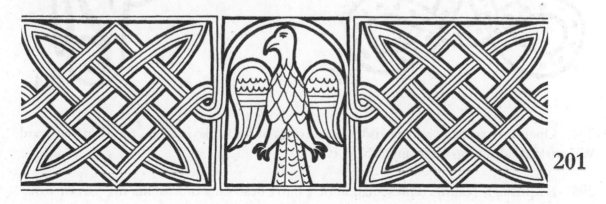

201

201 – Ornament on a sarcophagus slab from the church of St. Wawrzyniec in Zadar (Croatia), XI c. [71, p. 33]

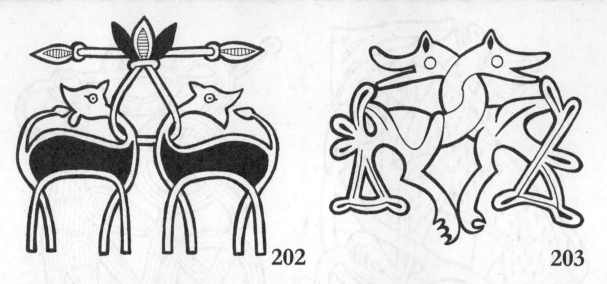

202 **203**

202 – Motif of opposing beasts encircled by a spiral hip (maybe the Tree of Life) on silver amulet receptacle kaptorg). The artifact bears pagan significance and was found in Chełm Drezdenecki, X-XI c. [32]

203 – Motif of interwoven zoomorphs on a silver amulet receptacle (kaptorg) excavated in Biskupin. One can notice Western European influences on local craftsmen, X/XI c. [22]

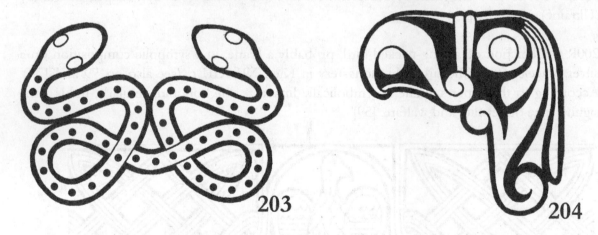

203 **204**

204 – Openwork snakes / adders visible on earrings of local, Slavic origin found in Starogard Wagryjski (Oldenburg/Germany), IX (?) c. [50]

205 – Surprisingly realistic representation of a bird's head on a bronze hilt tip, part of nahajka, a type of weapon typically associated with Volga Bulgars. Still, the ornamentation is of Scandinavian origin. Possibly, Scandinavians, and even Slavs, adopted this type of weapon from Bulgars, Alfta (Sweden), Early Middle Ages [30]

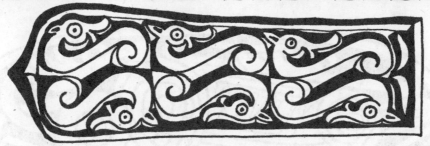

206

206 – Bronze end with a motif of stylized dragons is an example of Nomadic craft adopted by Slavic settlers, Hraničná nad Hornádom (Slovakia), IX c. [4]

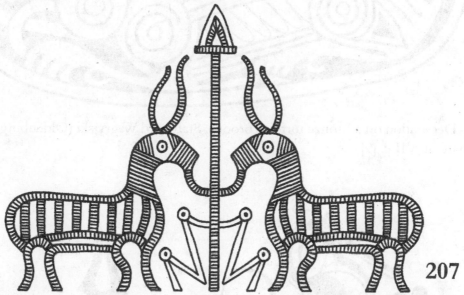

207

207 – Mythological-symbolical motif on an antler receptacle excavated from a Slavic, warrior- horseman's burial in Nin-Ždrijac (Croatia), 1st half of IX c. The motif depicts the Tree of Life with a totemic finish and standing by horses wearing ritual, horned masks covered with cloaks. Some experts refer this depiction to Avar, shaman beliefs where masked horses accompanied a dead person to the underworld. In such a case, the item, which was used by Slavs unfamiliar with Avar mythology, had purely aesthetic, rather than religious, value. The author, however, would like to propose a different stance, where a masked horse is associated with Veles/Triglav – Slavic deity of the underworld that bears a spear as its symbolic attribute. In this perspective, the imagery of the container can be considered on more familiar grounds of local beliefs, assuming that the container was manufactured locally. The author's stance was formulated on a basis of a detail visible in the representation, where one of the horses is visibly tied to a central axis, or a pole. Thus, the imagery can be linked with a re-enactment of a Slavic ritual, and cosmology, where Jarilo, one of the protagonists in Slavic mythology, revolves on a horse around the" pole of the world"(axis mundi, the Tree of Life) to signify cyclicality and infinity of cosmos. [17]

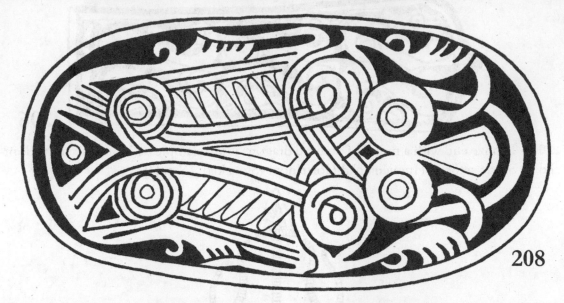

208 – Decoration on a bronze tortoise brooch, Starogard Wagryjski (Oldenburg / Germany), 2nd half of VII c. [9]

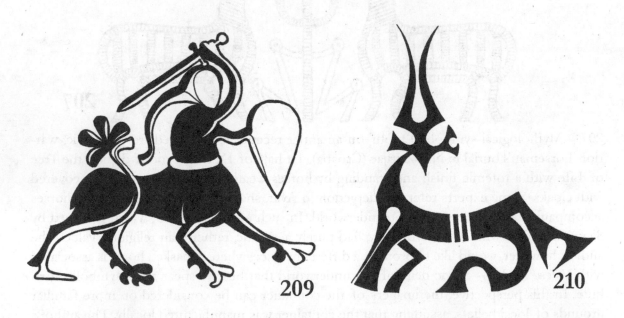

209 – Representation of a centaur visible on a flooring tile from the church in Tyniec, XIII c. [70. p. 238]

210 – Silver and copper incrusted deer imagery on the head of a ceremonial axe found in Gubin, XII c. [14]

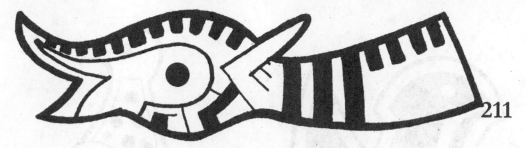

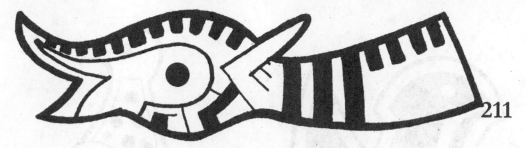

211 – Scandinavian design of an adder head visible on an unidentified object, Kał-dus, 2nd half of X - 1st half of XI c. [3]

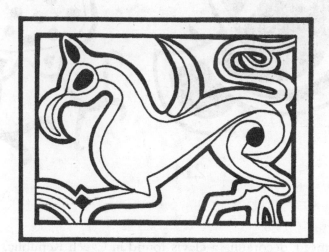

212- Griffin motif on an openwork, bronze ferrule, Nová Ves (Slovakia), VII-VIII c. [46]

213 – Another griffin representation common in Avar design, here visible on a bronze belt end, Debrecen-Ondód (Hungary), VIII-IX c. [48]

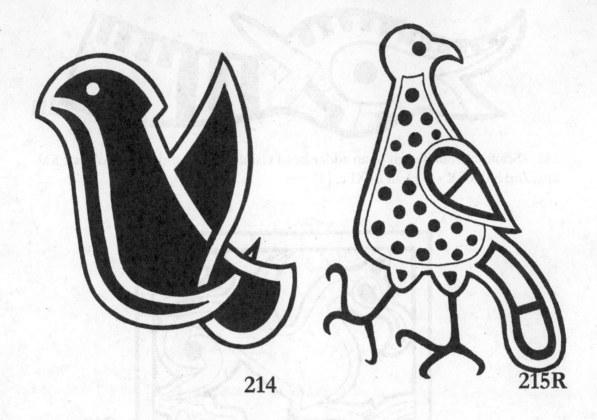

214 **215R**

214 – Bird motif decorating a clevis found in Czech Republic, IX-X c. (same clevis visible in no. 168) [22]

215R – Bird motif on an enameled, golden koltis (a piece of jewelry worn besides overhead garment indicating relationship to high classes of nobility in Kievan Rus XI-XIV c.) from Kiev. The bird motif supplanted preceding representations of vila (Slavic nymph) – mermaid, linked with aqueous symbolism, such as rain, vegetation and fertility that followed. The whole set of symbolical koltis was supposed to indicate the influence of Nature's elementals, worshipped by the Slavs, on vegetation and welfare. This pagan symbol functioned in Rus during the period of bireligion, when heathen motifs, vili, had to be replaced with stylized, less offensive symbols, such as the presented birds placed on both sides of the pagan" Tree of Life". This, in turn, is a reminiscence of another, similar pattern in koljadek showing creation of the world by two doves sitting on the Tree of Life – the ancient one that emerged from a preocean – chaos. The presented form comes from the middle of XII c. [59 and 65. p. 452]

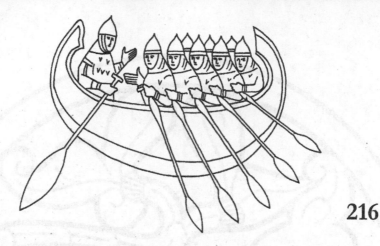

216

216 – Warrior boat from a wall painting in the church of St. Klimenta, Stará Boleslav (Czech Republic), end of XII c. [67, p. 123]

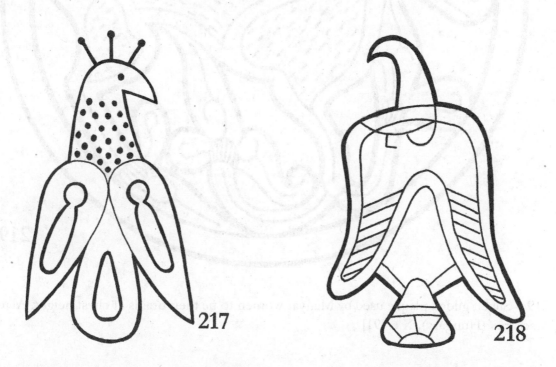

217

218

217 – Image of a bird carved on an antler plaque from Budec (Czech Republic), possible Great Moravian influences, end of XII c. [91]

218 – Eagle representation on a wooden amulet receptacle (kaptorg) symbolizing Slavic deity Perun, Wolin, X c. [11]

219

219 – Silver, gilded plaque used by Magyar women to tie their braids at chest height. Algebrő-Macsáros (Hungary), X c. [91]

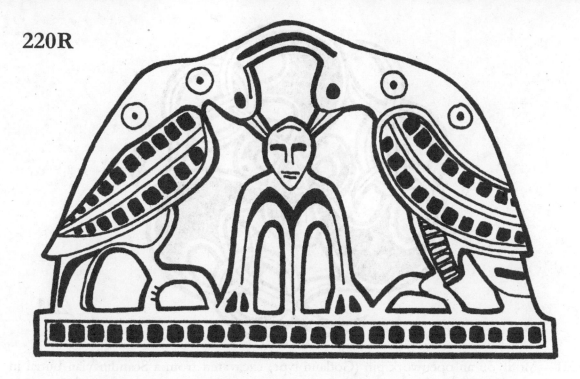

220R

220R – Symbolical-mythological representation of birds (ravens?) encircling and leaning to-wards (whispering to?) a human silhouette, visible on a flint grip excavated in Caucasian ter-ritory (similar item was also found in Kiev) and dated to the Early Middle Ages. Possibly, the ravens, widely recognized as a symbol of wisdom, foresight and understanding, should be interpreted like the ones depicted in Scandinavian mythology, namely as Odin's ravens (Hugin and Munnin or Thought and Memory). Furthermore, the ravens presented here can be in-terpreted in terms Nomadic influences, as guides in shamanistic trips (the mentioned Odin had a strong affiliation to shamanistic practices). [22]

221

221 – Motif on an openwork pin (Gotland type) excavated from a Scandinavian burial in Elbląg, 2nd half of VIII c.

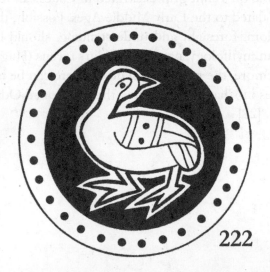

222

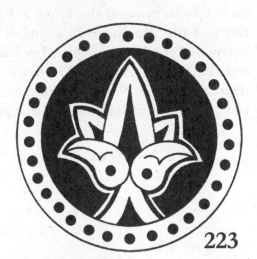

223

222 – Stylized bird motif inscribed in a circle. The motif was found carved on a Byzantine-style bracelet Tiszaeszlar-Bashalom (Hungary), 1st half of X c. [91]

223 – Stylized floral motif of Lotos inscribed in a circle. Here visible on a silver, Byzantine-style bracelet Tiszaeszlar-Bashalom (Hungary), 1st half of X c. [91]

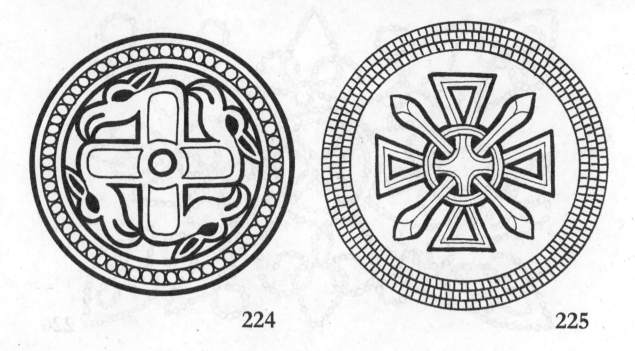

224 **225**

224 – Openwork, bronze plaque with a zoomorphic pattern, Bratislava – Devínska Nová Ves (Slovakia), VII-VIII c. [46]

225 – Motif of a stylized Maltese cross from a silver, convex, shield brooch Gåträsk (Sweden) 2nd half pf X c., (the significance of this symbol is explained in no. 232, see also 228, 231, 235, 236) [26]

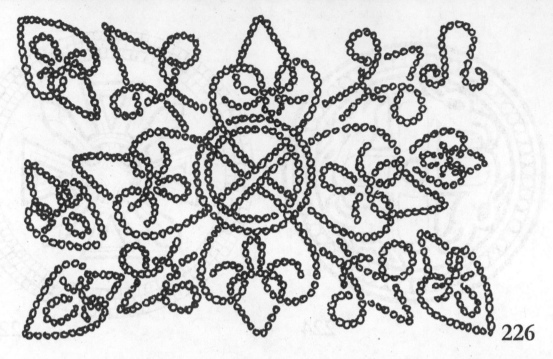

226 – Drawing of a granular pattern on a silver amulet receptacle (kaptorg) unearthed in Borucin. This type of ornamentation suggests Frankish influences, XI c. [5]

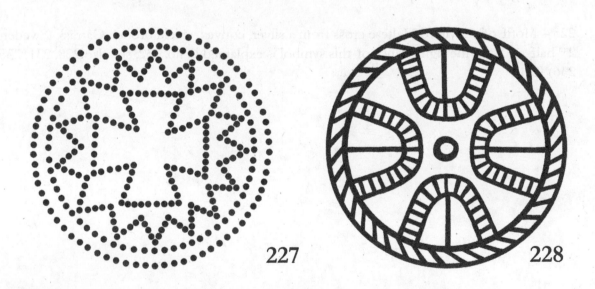

227– Motif from a reconstructed, wooden drinking vessel, Staré Město (Moravia) IX c. [22]

228 – Motif of a stylized Maltese cross from a silver, shield brooch, Mainz (Germany)

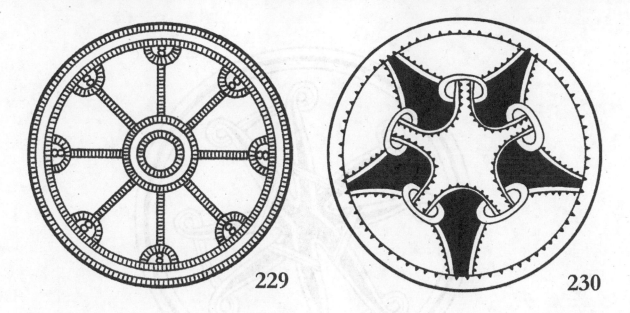

229 230

229 – Ornamentation on a silver-bronze pin Kurmaičiai-Pajuodupis (Lithuania), V-VI c. [19]

230 – Ornament at the bottom of a wooden ladle excavated in Opole, XII c. [81]

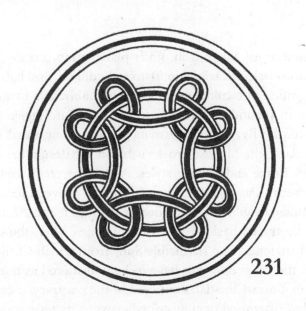

231

231 – Motif of a stylized Maltese cross from a silver, convex pin, Birka (Sweden), X c. (the significance of this symbol is explained in no. 232, see also 228, 231, 235, 236) [26]

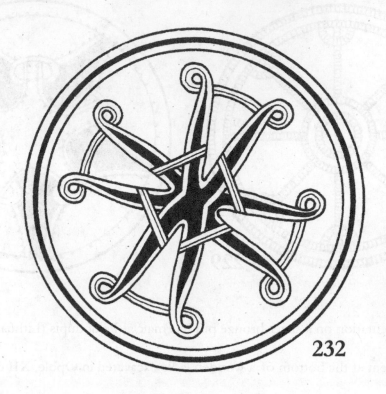

232

232 – Copper incrusted motif on an iron, silver-plated strap ferrule (possibly part of a sumptuous stirrup, sumptuous belt) excavated in Ostrów Lednicki, 2nd half of X c. or the beginning of XI c. The oval signifies elite culture and, most probably, was manufactured in the territory of Danish monarchy in Jutland as a transfiguration of Carolingian and Ottonic Art, which, in itself, was influenced by Byzantine, Merovingian and Longobard symbolism originating in Ancient imagery. Similarly, the Maltese cross visible in the design has been reinterpreted in the spirit of Scandinavian Borre and Jellinge styles. As for the cross itself, according to some authors the motif is closer to Pagan, rather than Christian, provenance. In this context, the cross symbolizes Christ affiliated with the Sun (bearer of Light, the Almighty Sun), the symbolic perspective that can be traced back to the Ancient times when the cult of Christ contended with solar cult of Sol Invictus (The Invincible Sun) from which Christ image adopted its solar attributes. Therefore, the cross does not have to be considered as purely Christian motif, even more so as it occurs in a non-Christian context. On the contrary, it can be referred back to the Ancient solar cults that oftenused oval inscribed cross in its representational practice (see also no. 225, 228, 231, 235, 236). [26]

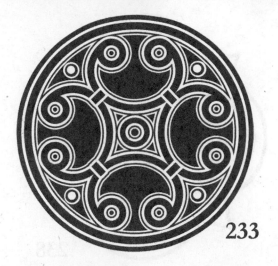

233

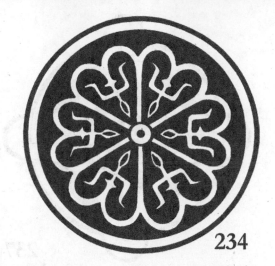

234

233 – Magical spiral common on shield brooches found in Scandinavia and Western-Slavic territory from IX-XI and up to XIII c. Items found in Trójca and Obry Nowa [68] bear the most significant Polish variants of the design [73]

234 – Motif from a silver plate, Ostrów Lednicki, X-XI w. [51]

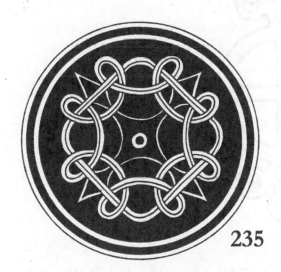

235

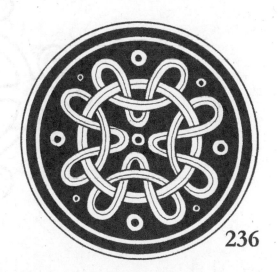

236

235 – Motif of a stylized Maltese cross on a golden, convex, shield brooch, Oppmannasee (Sweden), X c. (the significance of this symbol is explained in no. 232, see also 228, 231, 235, 236) [26]

236 – Motif of a stylized Maltese cross on a silver, convex, shield brooch, Oppmannasee (Sweden), X c. (the significance of this symbol is explained in no. 232, see also 228, 231, 235, 236) [26]

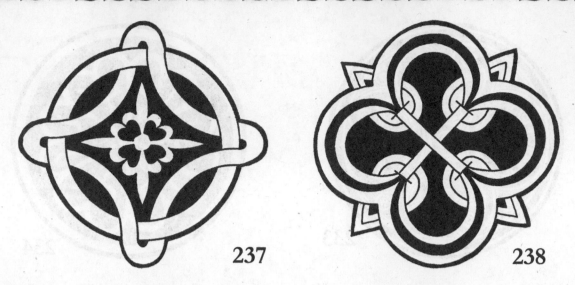

237

238

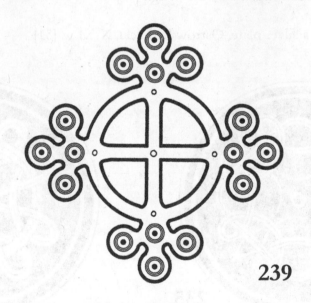

239

237 – Motif on a parquetry plaque from the church of St. Idzi in Inowłódz, XIII c. [66, p. 266]

238 – Ornament on a chair rest, Novgorod, beginning of XIII c. [22]

239 – Shape on a bronze, Baltic fibula, Upyna (Lithuania), IX-X c. [19]

240 – Geometric dendriform visible on silver stirrup ferrule from Magyar, princely barrow, Zeplin (Slovakia), X c. [91]

241 – Pattern on a bronze plate, Ostrów Lednicki, X-XI c. [51]

242 – Pattern on Magyar hair plaque made of gilded silver Biharkeresztes-Bethlen, (Węgry), end of IX c. [48]

243 – Pattern on a mould from Płock, XI c. [40]

244

245

244 – Embossed ornament from a rhomboidal extension of a ring made from a single piece of bronze plate Stěbořice (Czechy), 2nd half of IX c. [12]

245 – Ornament on a gilded-silver, Merovingian brooch, Linz (Germany), VII c. [91]

246

247

246 – Motif from one of the illuminations in "Ewangeliarz gnieźnieński", 2nd half of XI c. [65, p. 465]

247 – Symbol in the shape of an enclosed, spiral swastika on the Southern wall of St. Peter and Paul's monastery. The motif is a remainder of old mythology and symbolism that was incorporated into Christian doctrine when Christianity was being introduced. The monastery was erected 1120-1140 AD. [84]

248　　　　**249**

248 – One of possible variants of Slavic pottery trademarks in a swastika shape. It is believed that symbols of this sort were intended to bring welfare to the prospected users of the product, Czech Republic, X c.

249 – Fragment of an ornament found on a ladle, Ostrów Lednicki 1st half of XI c. [37]

250R

250R – Illumination ornament found in Codex Gertrude (daughter of Mieszko II and Rycheza, mother of Russian prince Jaropełk), XI c. The design of the illumination betrays plethora of influences and is a combination of Western-Romanesque, Polish and Rus-Byzantine styles. [66, p. 102]

251 – Motif from a knife scabbard chape found in Dziekanowice (Poland), 2nd half of XI c. - end of XII c. [63]

252 – Motif on a gilded-bronze belt plaque, Kalisz, VII c. [1]

253 – Motif from an antler bolster of nahajka decorated with bird's head, Lõhavere (Estonia) 2nd half of XII - 1st half of XIII c., possible symbolic significance [30]

254 – Ornament – symbol commonly used for decorating antler- and bonework, X-XII c. [39]

255R – Ornament – symbol on the outer side of a sword guard found in Zaporizhia. Still, the sword type, as well as the ornament, is of Carolingian origin, turn of X/XI c. (same item as the one presented in no. 82) [28]

256R – Ornament fragment from a scabbard shoe excavated in Minsk (Belarus), XI-XIII c. [54]

257R – Scabbard shoe pattern excavated in Litwinawiczi (Belarus), end of X – XI c. [54]

258 – Scabbard shoe with stylized bird (eagle? falcon?) ornament common in Eastern territories often visited by Vikings, also found in Wolin. The presented pattern, however, comes from Belarus, 2nd half of X -beginning of XI c. [54]

259R – Scabbard shoe found in Nowogródek (Belarus), XI-XIII c. [54]

260 – Graphical representation of an ornament from St. Vaclav's robe illuminated in "Kodeks Wyszechradzki", 1086 AD [91]

261 – Background detail on one of the pages of" Codex Egberti", Trier (Western Germany), ca. 977-993 AD [91]

262 – Decoration on a mould used for casting amulet receptacles, Haćki, VI c. [46]

263

264

265

263 - Pattern on a lime mould, Czwartek (Poland), VIII-IX c. [46]

264 — Engraved pattern on a ladle from Ostrów Lednicki. 2nd half of X - XI c. [75]

265 — Pattern on decorative, clay tablets, Preslav (Bulgaria), X c. [22]

266

267

268

269

266 – AA [22]

267 – Decoration on a stone slab found in Kracow Cathedral of St. Wacław, 1st half of XI c. [39]

268 – Motif on a wooden handle, Szczecin, 3rd quarter of XI c. [42]

269 – AA with a different filling variant [42]

270

271

272R

273R

270 – Decoration on thong ferrules, Staré Město (Morawy), turn of IX-X c. [22]

271 – Stylized triangular patterns were typical for the Middle Ages. The presented decoration was found on a piece of ladle, Ostrów Lednicki, 1st half of XI c. [31]

272R – Chair rest decoration found in Novgorod (Ukraine), beginning of XIII c. [22]

273R – AA [22]

274

274 – Post-Carolingian dendriform pattern on a T-shaped antler container, Ilanz (Switzerland). After the year 916 AD ornaments of this sort were common in Early Medieval Europe. It is believed that the design originated in the Middle East (Egypt) from where, through Roman Massillia, the ornament was imported by Franks and later adopted by Germanic and Iro-Scottish tribes. The author of the design based the presented motif on Iro-Carolingian patterns (see below no. 275) [17]

275

275 – AA [17]

276

276 – Ornament on a marble portal in the church of Zalavár (Hungary), IX c. [91]

277R

277R – Pattern on a slate slab from St. Sophia Orthodox chapel, Kiev (Ukraine), XI c. [22]

278 – Stone ornamentation with visible names of Croatian princes Drislav and Svetoslav, Knin (Croatia), ca. 970 AD [22]

279 – AA [22]

280

280 – Triple lane spiral hip on a pre-Romanesque, stone slab typical for its period during which Late Ancient influences were still retained in Medieval ornamentation, Zadar (Croatia), XI c. [71, p. 31]

281

281 – Dendriform pattern on a stone slab from Ostrów (Czech Republic), 2nd half of XII c. [22]

Expansion

RUS

282 – Motif from a rich symbolic set of ritual bracelets associated with spring time fertility and vilas – Rusalkas. The ornament symbolizes rain and was originally positional vertically, Kiev XII c. (see other decorations from the same bracelets 79, 134, 200, 293, 294, 295, 202) [59]

283 – Stylized dendriform carved on an antler object (possibly a plaque) from burial no. 6 of a Sjedniejewska group of barrows in the Czernihov area, X c. [57]

284 – Dendriform pattern decorating the southern arch of St. Sophia Orthodox chapel in Kiev. Most probably, the motif was painted by Byzantine (Greek) artists or their Rus students, first half of XI c. [56]

285

285 - AA [57]

286

286 – Convex, geometric ornament in Scandinavian Borre style found on a bronze strap end. The object was excavated from a cremated female burial in Gniezdowo and is analogous with other findings in Borre (Norway) and Gotland (Ihre). Similar long belt ferrules were also found in Ihre and Skopintull, close to Birka (Sweden), 2nd half of X c. (see also 287, 288, 289, 291) [57]

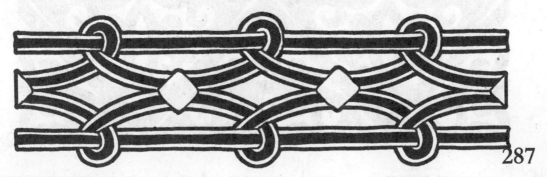

287

287 – AA [57]

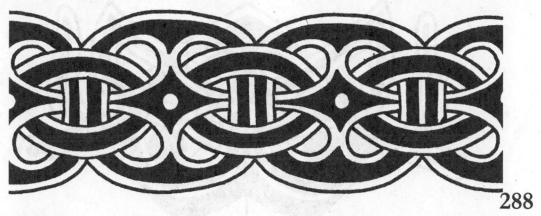

288

288 – AA [57]

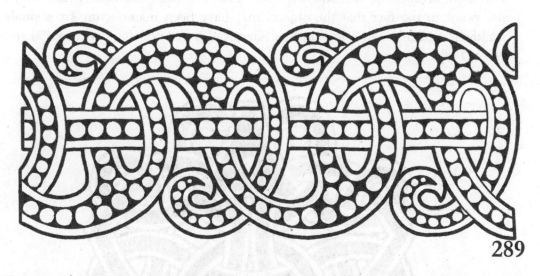

289

289 – Decoration made of spiral hips and dots in Mammen style carved on an antler handle by an experienced craftsman well acquainted with Scandinavian artistic trends. As for the sword itself, it could have been manufactured in Gniezdowo or Denmark. See also 286 [57, 8]

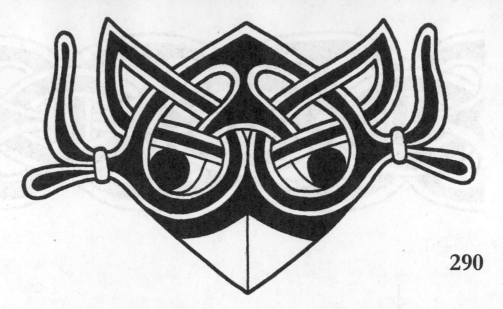

290

290 – Bird's head (?) as a fragment of a cloak pin decoration in Nordic style. Interestingly, artifacts of this sort were only found in Scandinavia and Rus, which may point to the fact that the objects may have been manufacture by a single Scandinavian craftsman living in Rus. Kiev, Rus, burial no. 108, between 950 and 990 AD [8]

291

291 – Spiral ornament on a cast bronze, stirrup ferrule in Borre style. Analogous findings occurred in Jutland, see no. 286 [57, 8]

292

293

294

295

292 – Rosette fragment from a sarcophagus found close to Kiev Orthodox chapel, Ukraine. XI-XII c. [27]

293 – Dendriform (the Tree of Life) shown on ritual bracelets from Kiev, XII c. For origin and context, see also 79, 134, 200, 282, 294, 295, 303 [59]

294 – Decoration symbolizing earth or water, both symbols belonging to the sphere of fertility associated with chthonic significance, Kiev XII c. For context and origin, see 79, 134, 200, 282, 293, 295, 303 [59]

295 – AA or a motif of blossoming vegetation, life, for context and origin see 79, 134, 200, 282, 293, 294

296 – Animal head with a spiral motif found on bronze cloak pin in Borre style, Gniezdowo, 2nd half of X c. Different ornament from the same pin in no. 197, for similar pin see 71 and 298

297 – Motif on a rim of the same pin as no. 296, for similar item see also 71 and 298 [57]

298

298 – Animal head with a spiral motif seen on a gilded cloak pin in Borre, Ringerike influenced style. Similar pins were also found in Sweden and Gotland. For a different ornament on the same pin, see no. 71. For similar pin decorations see no. 296, 297 [8]

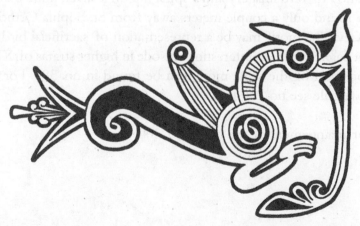

299

299 – Zoomorphic motif (dragon, griffin?), carved with almost naturalistic attention to detail, was manufactured locally in the Rus territory. Circular shapes on the animal's body are a reminiscence of Nordic influence. The object is considered to be a part of baldric, Gniezdowo, X c.

300

301

300 – Combination of bird imagery and a spiral hip on a silver, knife handle ferrule. Part of the treasure found only a couple meters away from St. Sophia Orthodox chapel in a royal part of Kiev. The motif may be a representation of sacrificial bird associated with the activity of a pagan witch, an interesting episode in higher stratas of XII c. Rus society. Another composition of the same motif can be found in no. 302. For a different bird from the same ferrule see no. 200 [59]

301 – Different arrangement of the motif no. 300

302 – Motif of two opposing birds guarding the Tree of Life. See no. 300 for symbolic meaning.

303 – Opposing birds motif interweaved with a spiral hip can be just another representation of the Tree of Life. Ornamentation from ritual bracelets; see also 79, 134, 200, 282, 293, 294, 295, Kiev XII c. [59]

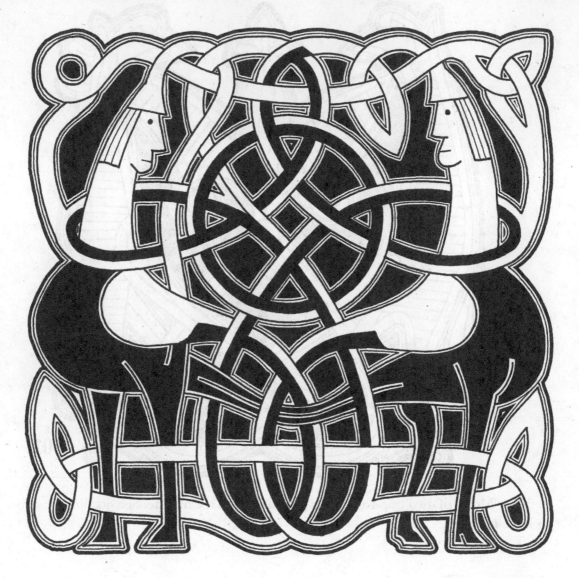

304

304 – Composition of diametrical figures with human heads and bird bodies surrounded by a complex, spiral ornament. The motif can be interpreted as a representation of Siemarglo or even Pereplut as guardians of the Tree of Life. The motif was found on a stone mould used for casting ritual bracelets (see also 79, 134, 200, 282, 293, 294, 295, 303), Kiev XII c. [59]

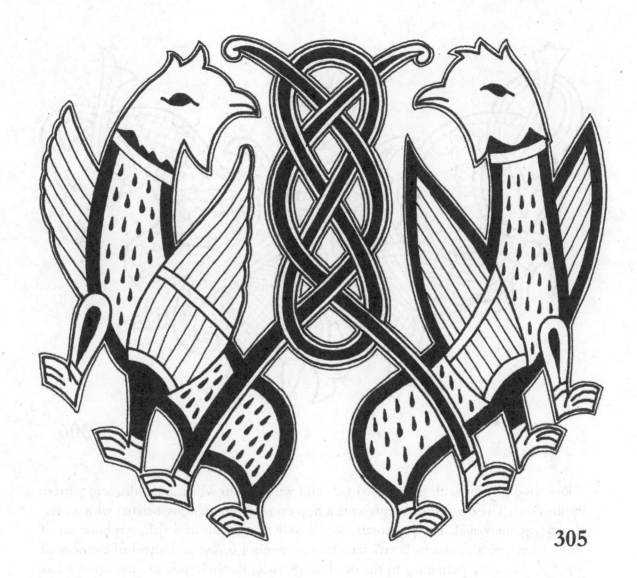

305

305 — Opposing griffins with tails tied together to form a symbol of aqueous significance. Similar patterns were found on ritual bracelets (see 79, 134, 200, 282, 293, 294, 295, 303, 305). As their vertical composition would suggest, the symbol is most probably a rain motif. The ornament comes from koltis (richly decorated Rus head cover) found in a lake close to Czernihov, 1st half of XII c. (see also 308) [59]

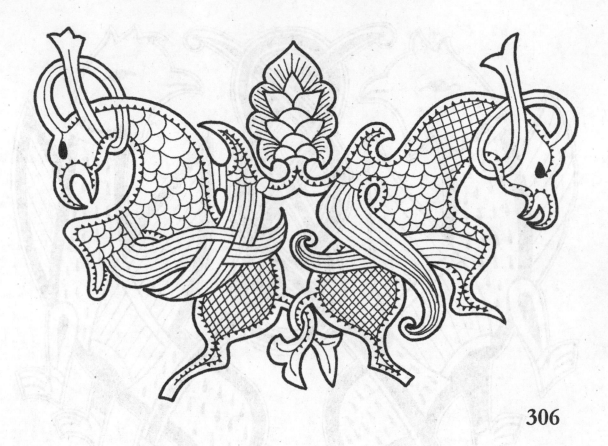

306

306 – Two griffins with intertwined tails and wings from which a dendriform pattern springs out. The dendriform represents a hop cone traditionally associated with a ceremony (e.g. marriage). The presented piece is only a fragment of a rich, symbolic set of decorations on an aurochs horn's ferrule. The symbol is just an individual element of a longer narrative pertaining to the death of Kościej Bezśmiertny. On the other hand, placing a cone in the ornament symbolizes the time of Kupala (summer solstice). In that perspective, the figure on the left represents spring, whereas the one on the right is summer. Another symbolic meaning lies in the fact that a cone ornament was placed on a drinking horn that is a vessel commonly used for ritual drinking of alcohol. There were two horns of that type found in "Czarna Mogila" (dark resting place), Czernihov X c. Other fragments of the same ornament are visible in 117, 156 [59, 60]

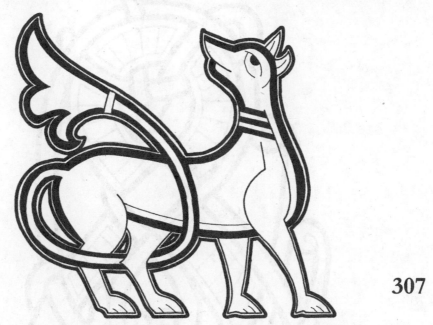

307

307 – Wolf imagery found on silver wrist bracelets, Gorodiszcze, XII-XIII c. [59]

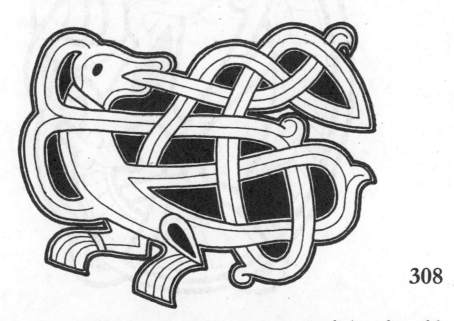

308

308 – Zoomorphic-spiral hip ornament representing Siemargła (guardian of the Tree of Life) devouring his own wings that intertwine with a spiral hip, decoration of silver koltis (see also 305), XII-XIII c. [59]

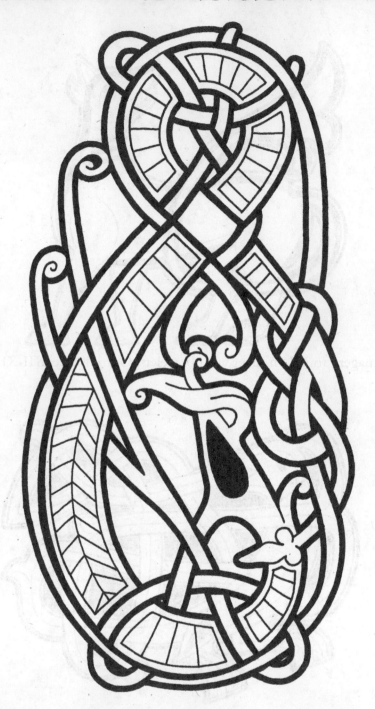

309

309 – Entangled zoomorphic figure in Urnes style (the lattest of Viking decorative styles) shown on a bronze, openwork ferrule manufactured in Gotland, but excavated in Novgorod, end of XI c. [57]

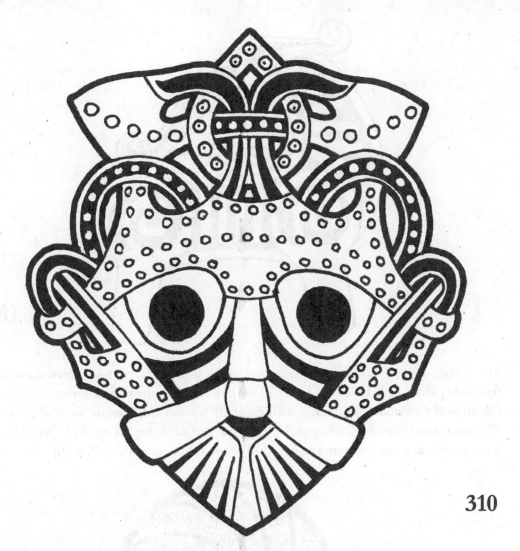

310

310 – Stylized man's face with beard and moustache or a mask decorating a cast pendant. Pendants of this type, with face representations, were manufactured in the 10th century. The shown example was made by jewelers from Gniezdow influenced by artists from Denmark and the court of Harald Bluetooth. The treasure was found in Centralnoje Gorodiszcze in Gniezdowo, X c. (for different artifacts from the same treasure see 311, 313, 314, 315) [8]

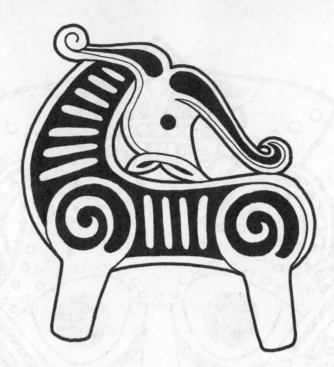

311

311 – Four-legged, horned creature (ram, goat, deer), one of four three-dimensional figurines placed on a base of a heavy cloak pin. Similar pins were excavated in Sweden, Öland and Gotland. Ornaments with similarly positioned animals were also found in Södermanland (Sweden). Pin rim decorating motif is shown in no. 314. For other artifacts from the same treasure see 310, 313, 314, 315, Gniezdowo, X c. [8]

312

312 – Concentric, equilateral motif (sun? shield?) on a high-quality silver pendant with filigree ornament from, so called, "włodzimierski" barrow, found in Nerl, X c.

313

313 – "Clutching beast" motif common in X c. Scandinavia. Here presented as two animals positioned in a mirror image. Similar ornaments were found close to Mälar Lake territory in Sweden, which is known for its trade contacts with Rus. (for other artifacts from the same treasure see 310, 311, 314), Gniezdowo, X c. [8]

314

314 – Geometric ornament filled with bird heads on a disc that was once part of a massive cloak pin. For other fragments of the same pin, see no. 311. Other artifacts from the same site are 310, 311, 313, 315, Gniezdowo, X c. [8]

315

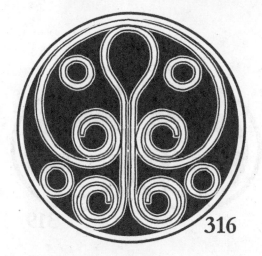

316

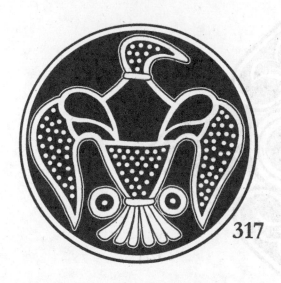

317

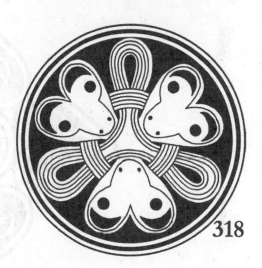

318

315 – Two-headed bird with spread wings, probably a falcon, motif seen on a silver pendant manufactured with traceable influences of Slavic, Volhynian jewelers (different artifacts from the same site are 310, 311, 313, 314), Gniezdowo, 2nd half of. X c. [8]

316 – Volute and "omega" motif on a circular pendant found in Centralnoj Gorodiszcze in Gniezdowo, X-XI c. [8, 57]

317 – Bird (falcon?) imagery on a circular pendant cast in a low-quality silver, Novgorod, X c.

318 – Ornament made of three zoomorphic masks in Borre style from a gilded bronze, circular fibula, Gniezdowo, X c. [57]

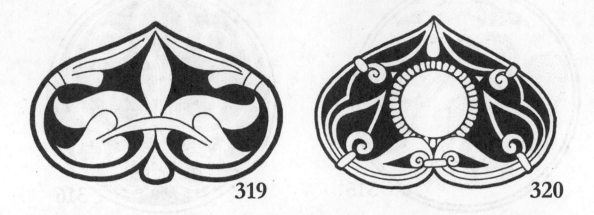

319 320

321

319 – Heart-shaped pattern from a bronze strap end. Similar ends were found in Eastern Nomadic tribe burials, but this particular decoration reached Rus via Bulgaria, Gniezdowo, barrow 18, X c. [57]

320 – Different, heart-shaped belt ferrule also of Nomadic origin found in Gołubiszcze barrow in Czernihov, X c. (different ferrule from the same belt is visible in no. 322, different artifact from the same barrow 321) [57]

321 – Dendriform motif from rectangular, gilded bronze caftan clasps excavated in Gołubiszcze, Czernichov, X c. (see also 320) [57]

322 – Different ferrule from the same belt as no. 320 [57]

323 – Motif from a heart-shaped, bronze belt ferrule in Nomadic style imported from Bulgaria, Kirilino, barrow 89, burial 2, X c. [57]

324 – Motif from a heart-shaped, bronze belt ferrule in Nomadic style imported from Bulgaria, Gniezdowo, barrow c-160, X c. [57]
325 - Motif from a heart-shaped, bronze belt ferrule in Nomadic style imported from the East, Gniezdowo, barrow 26, X c. [57]

326

327

326 – Trident, a symbol that evolved from an earlier bident symbolizing Rurik dynasty, was introduced by Vladimir the Great at the end of the 10th century. Only the most prominent members of royal dynasty elite were allowed to use this symbol for decorating objects. The origin of this sign is still unclear, yet, according to some theories, trident can be symbolically associated with falcon motif, intersection of a Scandinavian ship, Nomadic tamga, or even an arrow-head in its archaic bidental form. The presented pattern comes from a cast pendant found in Novgorod, dated to ca. 1002-1025 (see also 327) [8]

327 – Trident motif (see no. 326 for symbol origin) visible on a coin from the period of Vladimir the Great, end of X c.

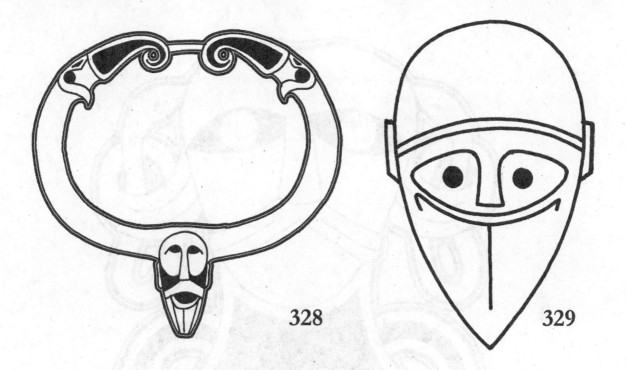

328

329

328 – Three-dimensional figure of a horned man. Motif commonly associated with the cult of Odin. The ornament is supposed to represent Odin's worshipper-intermediary. The motif is common in Germanic culture and starts appearing from VI c. on in Sweden, England, Denmark and among continental Germanic tribes. The presented example bears a finial consisting of two birds (eagles, falcons) and was manufactured in a style from the Vendel period. The object has a strong magical significance and stands for a high social status, Stara Ładoga, end of VII-beginning of VIII c. [8]

329 – Face or mask on a silver object that is believed to be a part of broadsword grip. The object was found in an iron cauldron filled with goat remains. According to some theories, the object is a part of sacrificial knife used in ritual killing (Ibn Fadlan mentions that such knives were in use during the offerings). Different interpretation claims that the mentioned object is a vertical loom shuttle used for yarn layering. Still, weaving also had a close affiliation to magic, so regardless of the interpretation, one may assume that the object held strong, ritual and mythological significance, Gniezdowo, barrow 16, X c. [8, 57]

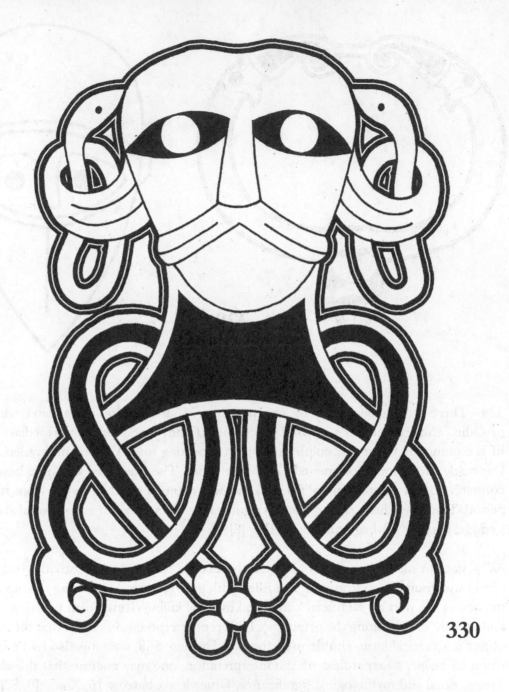

330

330 – Man's head with moustache, whose hair visibly transform into snakes. Ornamentation detail was found on a pin from Denmark. Mould for casting identical cloak pins was excavated in Stara Ładoga, dated to ca. 930-960, [8]

331

332

331 – Stylized bird imagery from a garment hook used to tie trousers or braids, Bolszoje Timiriew. Identical hook was found in Gniezdowo, X c. [8]

332 – Stylized bird motif from a silver pendant found in, so called, "Vladimirian Barrows" close to the Nerl River, X c. [8]

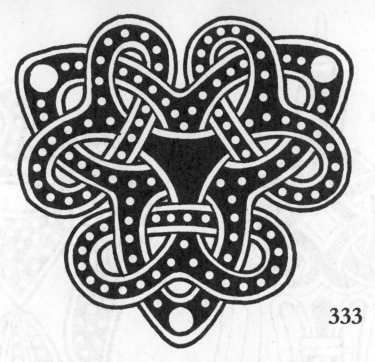

333

333 – Spiral pattern from a circular pin manufactured in Gniezdowo from, so called, "Vladimirian Barrows" close to the Nerl River, X c. [8]

334

334 – Rosette of Byzantine style and design, decorating a metropolitan throne found in St. Sophia's Orthodox chapel in Kiev, 2nd half of XI c. [56]

335

335 – Geometric pattern of overlapping circles decorating a plaque, Holmr – Riuri-kowo Gorodiszcze, X c. [27]

336

336 – Dendriform imitating incrustation on one of the walls from St. Sophia's Orthodox chapel, XI c. See also 340, 341, 342.

337

337 – Geometric decoration of a plaque-ferrule. Wozniesjenka village burial, VIII c. [87]

338

338 – Pendant decorated with two horse heads, Podjelje, barrow 103, X c. [57]

339

339 – Zoomorphic-dendriform pattern and, at the same time, a narrative motif representing a predator during a deer hunt. Decoration found on a belt ferrule is of Khazar origin and comes from the Zarajskij treasure, turn of IX/X c. [57]

340

340 – Relief decoration on a balustrade in St. Sophia's Orthodox chapel in Kiev, XI c.
See also 336, 341, 342 [56]

341

341 – AA [56]

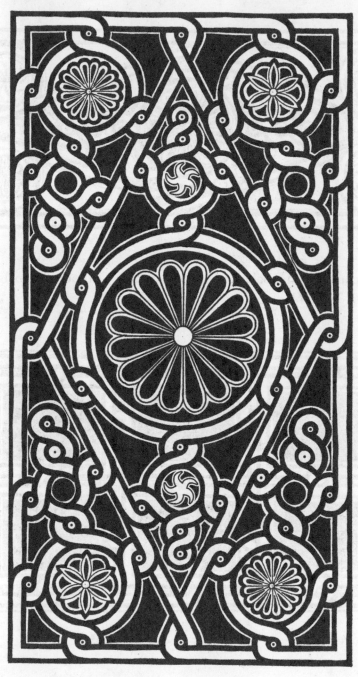

342 – AA [56]

342

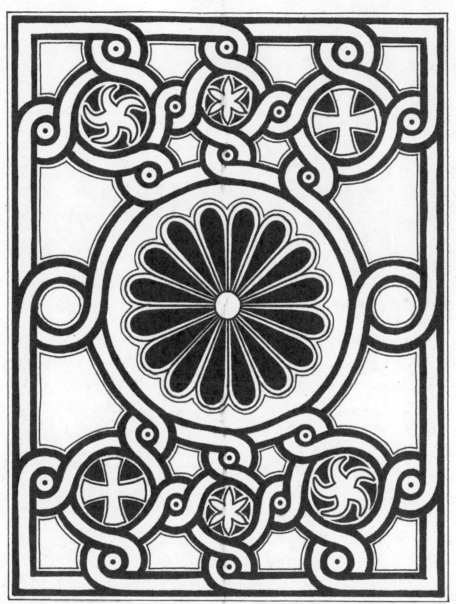

343

343 – AA [56]

SOURCES:

Abbreviations:

"Instantia" – E. Wilgocki (ed.), *Instantia est Mater Doctrinae*, Szczecin 2001.

"Kraje..." – Kóčka-Krenz H., Łosiński W. (ed.), *Kraje słowiańskie w wiekach średnich. Profanum i sacrum*, Poznań 1998.

"Kultura..." – Dowiat J. (ed.), *Kultura Polski średniowiecznej X-XIII w.*, Warszawa 1985.

"Mosty" - Kurnatowska Z. (ed.), *Wczesnośredniowieczne mosty przy Ostrowie Lednickim. Vol. I, Mosty traktu gnieźnieńskiego*, Lednica - Toruń 2000.

"Oldenburg..." - *Oldenburg – Wolin – Staraja Ladoga – Novgorod – Kiev. Handel und Handelsverbindungen im südlichen und östlichen Ostseeraum während des frühen Mittelalters. Internationale Fachkonferenz der DeutschenForschungsgemeinschaft vom 5.-9. October 1987 in Kiel*, Mainz am Rhein 1988.

"Pocz. Pań." - Tymieniecki K. (ed.), *Początki państwa polskiego. Księga tysiąclecia*, reprint, Poznań 2002.

"Słowianie..." – Dulinicz M. (ed.), Słowianie i ich sąsiedzi we wczesnym średniowieczu, Lublin – Warszawa 2003.

„Studia..." – Z. Kurnatowska (ed.), *Studia Lednickie, Vol. I-VIII*, Lednica 1989-2005.

Bibliography:

1. Baranowski T., *Okucie pasa z Kalisza*, in: "Słowianie...", pp. 225-229.

2. Bukowski Z., *Puste kabłączki skroniowe typu pomorskiego*, Szczecin 1960.

3. Chudziak W., *Wczesnośredniowieczne "importy" skandynawskie z Kałdusa pod Chełmnem na Pomorzu Wschodnim*, in: "Słowianie...", pp. 117-126.

4. Deka J., *Wielkie Morawy. Epoka i sztuka*, Bratyslawa 1979.

5. Dowiat J., *Pogląd na świat*, in: "Kultura...", pp. 169-192.

6. Dowiat J. (ed.), *Kultura Polski średniowiecznej X-XIII w.*, Warszawa 1985.

7. Duczko W., *Obecność skandynawska na Pomorzu i słowiańska w Skandynawii we wczesnym średniowieczu*, in: "Salsa Cholbergiensis. Kołobrzeg w średniowieczu" Leciejewicz L. (ed.), Kołobrzeg 2000.

8. Duczko W., *Ruś wikingów*, Warszawa 2006.

9. Dulinicz M., *Kształtowanie się Słowiańszczyzny Północno-Zachodniej*, Warszawa 2001.

10. Dulinicz M. (ed.), *Słowianie i ich sąsiedzi we wczesnym średniowieczu*, Lublin – Warszawa 2003.

11. Filipowiak W., Gundlach H. (ed.), *Wolin Vineta. Die tatsächliche Legende vom Untergang und Aufstieg der Stadt*, Rostock 1992.

12. Foltyn E. M., *Podstawy gospodarcze wczesnośredniowiecznej społeczności plemiennej na Górnym Śląsku*, Katowice 1998.

13. Gabriel I., *Hof- und Sacralkultur sowie Gebrauchs- und Handelsgut im Spiegel der Kleinfunde von Starigard/Oldenburg*, in: "Oldenburg", pp. 103-291.

14. Geremek B., *Polska w geografii kulturowej średniowiecznej Europy*, in: "Kultura...", pp. 8-26.

15. Golczewski K. (ed.), *Tysiąc lat nad Odrą i Bałtykiem*, Szczecin 1966.

16. Górecki J., *Gród na Ostrowie Lednickim na tle wybranych ośrodków grodowych pierwszej monarchii piastowskiej*, Lednica-Poznań 2001.

17. Górecki J., *Ze studiów nad rozwojem, pochodzeniem oraz funkcją trzyczęściowych rogowych pojemników okresu wczesnego średniowiecza*, in: "Studia", Vol. VIII, pp. 89-129.

18. Grant J., *An Introduction to Viking Mythology*, New Jersey 2002.

19. Griciuviené E., *Baltiškojo ornamento Beieškant*, Wilno 1991.

20. Grupa M., *Sprzęt i wyposażenie gospodarstwa domowego*, in: "Mosty", pp. 139-162.

21. Hensel W., *Polska przed tysiącem lat*, Wrocław-Warszawa-Kraków 1967.

22. Hensel W., *Słowiańszczyzna wczesnośredniowieczna. Zarys kultury materialnej*, Warszawa 1965.

23. Indruszewski G., *Technical Aspects of Sail representations on gotland's runic stones: anonparametric approach*, in: "Instantia", pp. 261-269.

24. E. Wilgocki (ed.), *Instantia est Mater Doctrinae*, Szczecin 2001.

25. Kara M., *Wczesnośredniowieczny grób uzbrojonego kupca z miejscowości Ciepłe na Pomorzu Gdańskim w świetle ponownej analizy chronologicznej*, in: "Kraje...", pp. 505-524.

26. Kara M., Wrzesiński J., *Ozdobne okucie z grodziska na Ostrowie Lednickim. Przyczynek do studiów nad kulturą elitarną monarchii pierwszych Piastów*, in: "Słowianie...", pp. 393-405.

27. Karger M.K., *Dawny Kijów*, in: "Śladami dawnych kultur. Dawna Ruś", pp. 45-98.

28. Kirpicznikov A.N., *Driewnierusskoje orużyje. Wypusk 1. Mieczi i sabli*, Moskwa-Leningrad 1966.

29. Kirpicznikov A.N., *Driewnierusskoje orużyje. Wypusk 2. Kopia, sulicy, bojewyje tapary, bulawy, kistieni IX-XIII ww.*, Moskwa-Leningrad 1966.

30. Kokowscy E. i A., *Nahajki z rękojeścią w kształcie ptasich głów z Grudka nad Bugiem*, in: "Słowianie...", pp. 355-364.

31. Kola A., Wilke G., *Mosty sprzed tysiąca lat. Archeologiczne badania podwodne przy rezydencji pierwszych Piastów na Ostrowie Lednickim*, Toruń 2000.

32. Kostrzewski J., *Pradzieje Pomorza*, Ossolineum 1966.

33. Kóčka-Krenz H., *Biżuteria północno-zachodnio-słowiańska we wczesnym średniowieczu*, Poznań 1993.

34. Kóčka-Krenz H. (ed.), *Poznań we wczesnym średniowieczu. Vol. V.*, Poznań 2005.

35. Kóčka-Krenz H., Łosiński W. (ed.), *Kraje słowiańskie w wiekach średnich. Profanum i sacrum*, Poznań 1998.

36. Kóčka-Krenz H., Sikorski A., *Grób "księżniczki" z Dębczyna koło Białogardu w woj. koszalińskim (stan. 53)*, in: "Kraje...", pp. 525-535.

37. Kurnatowska Z. (ed.), *Wczesnośredniowieczne mosty przy Ostrowie Lednickim. Vol. I, Mosty traktu gnieźnieńskiego*, Lednica - Toruń 2000.

38. Labuda G., *Fragmenty dziejów Słowiańszczyzny Zachodniej*, Poznań 2002.

39. Lalik T., *Poczucie piękna*, w: "Kultura...", pp. 375- 431.

40. Leciejewicz L., *Słowianie Zachodni. Z dziejów tworzenia się średniowiecznej Europy*, Ossolineum 1989.

41. Łęga W., *Kultura Pomorza we wczesnym średniowieczu na podstawie wykopalisk*.

42. Łosiński W. (ed.), *Szczecin we wczesnym średniowieczu. Wschodnia część suburbium*, Szczecin 2003.

43. Łosiński W., *Trójramienna zapinka skandynawska z cmentarzyska w Świelubiu pod Kołobrzegiem – aspekt chronologiczny*, in: "Słowianie...", pp. 133-139.

44. Matuszewska-Kola W., *Przedmioty z kości i poroża*, in: "Mosty", pp. 201-206.

45. Marek L., *Wczesnośredniowieczne miecze z Europy Środkowej i Wschodniej. Dylematy archeologa i brionioznawcy*, Wrocław 2004.

46. Miśkiewicz M. (ed.), *Słowianie w Europie wcześniejszego średniowiecza. Katalog wystawy*, Warszawa 1998.

47. Moździoch S. (ed.), *Wędrówki rzeczy i idei w średniowieczu, Spotkania Bytomskie Vol. V*, Wrocław 2004.

48. Nepper I.M., Grossman A., *Skarby Węgierskich Stepów*, Biskupin 2002.

49. Nosow E. N., *Nowyje Dannyje o Slavjanskich Pasjeljenjach Nowgarodzkaj okrugi*, in: "Slavia Antiqua", Vol. XXXIII, 1991/1992, W. Hensel, Z. Hilczer-Kurnatowska (ed.), pp. 65-93.

50. *Oldenburg – Wolin – Staraja Ladoga – Novgorod – Kiev. Handel und Handelsverbindungen im südlichen und östlichen Ostseeraum während des frühen Mittelalters. Internationale Fachkonferenz der DeutschenForschungsgemeinschaft vom 5.-9.* October 1987 in Kiel, Mainz am Rhein 1988.

51. *Ostrów Lednicki*, album, Bydgoszcz 2002.

52. *Parczewski M., Wczesnośredniowieczny trzewik pochwy miecza z Rybiczyzny, pow. Lipsko*, in: "Słowianie...", pp. 147-154.

53. Piotrowski A. (ed.), *Zabytki z okresu wpływów rzymskich, średniowiecza i czasów nowożytnych z Białorusi w zbiorach Państwowego Muzeum Archeologicznego w Warszawie*, Warszawa 2005.

54. Plawicki M.A., *Klinkowaja zbroja X-XIII stst. na terytoryi Bjelarusi*, Mińsk 2006.

55. *Początki Państwa Polskiego. Księga tysiąclecia*, reprint, Poznań 2002.

56. Puszko W., *Djekoratiwnoje ubranstwo interjora Sofii Kijewskoj*, in: "Slavia Antiqua", Vol. XXXIII, 1991/1992, W. Hensel, Z. Hilczer-Kurnatowska (ed.), pp. 131-159.

57. *Put iz Warjag w Grieki i iz Grieki...*, katalog wystawy, Moskwa 1996.

58. Roesdahl E., *Denmark – a thousand years ago*, in: Urbańczyk P. (ed.), *Europe around the year 1000*, Warszawa 2001, pp. 351-366.

59. Rybakow B. A., *Jazycziestwo drewniej Rusi*, Moskwa 2001.

60. Rybakow B. A., *Stołeczne miasto Czernihów i udzielny gród Wszczyż*, in: "Śladami dawnych kultur. Dawna Ruś", pp. 101-163.

61. Sarnowska W., *Miecze wczesnośredniowieczne w Polsce*, in: "Światowit" Vol. XXI, Warszawa 1955.

62. Schuldt E., *Der altslawische Tempel von Gross Raden*, Schwerin 1976.

63. Sikorski A., Wrzesińka A., Wrzesiński J., *Tkaniny z grobów*, in: "Studia", Vol. V, pp. 71-94.

64. Słowiński S., *Wpływy skandynawskie w dekoracji drewnianych przedmiotów codziennego użytku ze szczecińskiego podzamcza*, in: "Terra Transoderana. Sztuka Pomorza Nadodrzańskiego i dawnej Nowej Marchii w średniowieczu", M. Glińska (ed.), Szczecin 2004, pp. 173-188.

65. *Słownik Starożytności Słowiańskich*, ed. W. Kowalenko, G. Labuda, T. Lehr-Spławiński, Vol. I. Ossolineum 1961.

66. *Słownik Starożytności Słowiańskich*, W. Kowalenko, G. Labuda, T. Lehr-Spławiński (ed.), Vol. II, Ossolineum 1964.

67. *Słownik Starożytności Słowiańskich*, W. Kowalenko, G. Labuda, Z. Stieber (ed.), Vol. III, Ossolineum 1967.

68. *Słownik Starożytności Słowiańskich*, G. Labuda, Z. Stieber (ed.), Vol. IV. Ossolineum 1970.

69. *Słownik Starożytności Słowiańskich*, G. Labuda, Z. Stieber (ed.), Vol. V. Ossolineum 1975.

70. *Słownik Starożytności Słowiańskich*, G. Labuda, Z. Stieber (ed.), Vol. VI. Ossolineum 1977.

71. *Słownik Starożytności Słowiańskich*, G. Labuda, Z. Stieber (ed.), Vol. VII. Ossolineum 1982.

72. Soroka E., *Nieznany relikwiarz z Ostrowa Lednickiego*, in: "Studia", Vol. III, pp. 127-149.

73. Stanisławski B., *"Jomsvikingasaga" a archeologia*, in: "Wolin – emporium handlowe nad Bałtykiem" B. Stanisławski, W. Filipowiak (ed.), w druku.

74. Stanisławski B., *Sztuka skandynawska z Wolina*, in: "Średniowiecze Polskie i Powszechne", Vol. 4, Katowice 2007.

75. Stępnik T., *Średniowieczne wyroby drewniane z Ostrowa Lednickiego – analiza surowcowa*, in: "Studia" Vol. IV, pp. 261-296.

76. *Studia Lednickie*, Vol. I, Z. Kurnatowska (ed.), Lednica-Poznań 1989.

77. *Studia Lednickie*, Vol. II, Z. Kurnatowska (ed.), Lednica-Poznań 1991.

78. *Studia Lednickie*, Vol. III, Z. Kurnatowska (ed.), Lednica-Poznań 1994.

79. *Studia Lednickie*, Vol. IV, Z. Kurnatowska (ed.), Lednica-Poznań 1996.

80. *Studia Lednickie*, Vol. V, Z. Kurnatowska (ed.), Lednica-Poznań 1998.

81. *Studia Lednickie*, Vol. VI, Z. Kurnatowska (ed.), Lednica-Poznań 2000.

82. *Studia Lednickie*, Vol. VII, Z. Kurnatowska (ed.), Lednica-Poznań 2002.

83. *Studia Lednickie*, Vol. VIII, Z. Kurnatowska (ed.), Lednica 2005.

84. Szwarc-Bronikowski S., *Testament wieków*, Warszawa 1997.

85. Świątkiewicz P., *Uzbrojenie wczesnośredniowieczne z Pomorza Zachodniego*, Łódź 2002.

86. Trawkowski S., *Troska o pożywienie*, in: "Kultura...", pp. 29-58.

87. Tretjakow P.N., *Początki dawnej Rusi*, in: "Śladami dawnych kultur. Dawna Ruś", pp. 9-41.

88. Urbańczyk P. (ed.), *Europe around the year 1000*, Warszawa 2001.

89. Urbańczyk P. (ed.), *Origins of Central Europe*, Warszawa 1997.

90. Weisbecker J. (ed.), *Oldenburg – Wolin – Staraja Ładoga – Novgorod – Kiev. Handel und Handelsverbindungen im Suedlichen und östlichen Ostseeraum während des frühen Mittelalters*, Meinz 1988.

91. Wieczorek A., Hinz H.-M. (ed.), *Europas Mitte um 1000. Katalog*, Stuttgart 2000.

92. Wrzesiński J., *Misa brązowa z cmentarzyska w Dziekanowicach – próba interpretacji*, in: "Studia", Vol. VI, pp. 185-201.

93. Vana Z., *Świat dawnych Słowian*, Artia, Interpress 1985.

94. Żurowski K., *Gniezno – stołeczny gród pierwszych Piastów w świetle źródeł archeologicznych*, in: "Pocz. Pań" pp. 61-9

Look for more books from Winged Hussar Publishing, LLC – E-books, paperbacks and Limited Edition hardcovers. The best in history, science fiction and fantasy at:

https://www. wingedhussarpublishing.com
or follow us on Facebook at:
Winged Hussar Publishing LLC
Or on twitter at:
WingHusPubLLC
For information and upcoming publications

Look for our additional publications in conjunction with Triglav Books